Wisdom

MOMENTS OF MINDFULNESS FROM INDIAN SPIRITUAL LEADERS

Danielle & Olivier Föllmi

Wisdom

MOMENTS OF MINDFULNESS FROM INDIAN SPIRITUAL LEADERS

The Bhagavad Gita • Chandralekha • Mahatma Gandhi • Kabir • Krishnamurti
Acharya Shri Mahapragya • Guru Nanak • Nisargadatta Maharaj • Swami Prajnanpad
Maa Purnananda • Rabindranath Tagore • Rig Veda • Swami Vivekananda • The Upanishads

Abrams, New York

Foreword

Its natural landscape encompasses all that the world has to offer: endless snows, breathtaking peaks, deserts, luxuriant forests, plains furrowed with wide rivers, a huge range of colours and scents. Its culture is an inexhaustible reservoir; a treasure trove of all that humanity can offer us. Its incomparable diversity surely comes from the fact that for more than three thousand years, India has never rejected nor eliminated any part of its history or achievements. It is at once a land of the silence of meditation and the voice of prayer, a land of subtle logic and the spell of sensuality, a land of fervent passions and calm equanimity. Its melody is that of a thousand words and songs, whether from village huts under serene night skies or from the incessant hustle and bustle of the megalopolis. No wonder, then, that in its myths, concepts of good and evil are not always easily distinguished from one another. In both philosophy and life, illusion and its manifestations merge into a fantasical play, like an image and its evanescent reflection. Here as nowhere else, intense emotion and philosophical detachment

can transform everyday reality: the rhythmic movements of artisans with their time-honoured skills; the bustle of the bathhouses; the pungent aromas of cuisine; the innocent smiles of the children; even the busy work of computer programmers. The wisdom of India offers a unique itinerary of thoughts and images. This itinerary is born from the diversity of nature and people and ends in the realms of the spirit, invoking the divine through the unique and eternal face of humanity.

Giuliano Boccali

COSMIC LAW

One drop of the sea cannot claim to come from one river,
and another drop of the sea from another river;
the sea is a single consistent whole.
In the same way, all beings are one;
there is no being that does not come from
the soul and is not part of the soul.

The Chandogya Upanishad (*c.* 500 BCE)

In Sikkim, a torrent descends from the Himalayas, the home of the gods.

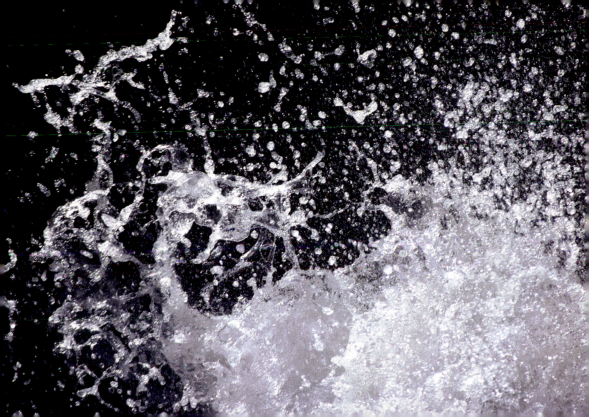

Each type of living being is distinct and different.
But when we pierce the veil of difference,
we see the unity of all beings.

The Shvetashvatara Upanishad (*c.* 400–200 BCE)

Monsoon season in Tamil Nadu.

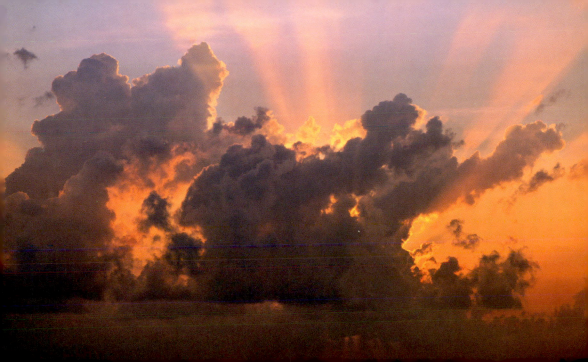

All humanity shares the sunlight;
that sunlight is neither yours nor mine.
It is the life-giving energy which we all share.
The beauty of a sunset, if you are watching it
sensitively, is shared by all human beings.

Krishnamurti (1895–1986)

Fresh water feeds the Kerala canals, which line the Arabian Sea.

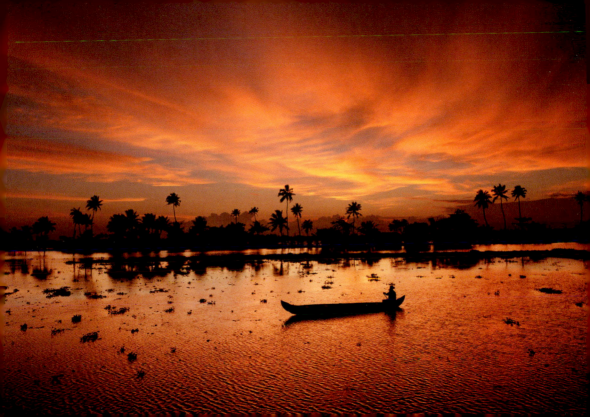

Unity in diversity is the order of the universe.
Just as we are all human, we are all distinct.
As a human being, I am like you.
As Mr. X, I am different from you.
As a man, you are different from a woman,
but in being all humans, we are one.
In that you are alive, you are as the animals and all that lives,
but as a human being, you are distinct.

Swami Vivekananda (1863–1902)

Students from a dance school in Kerala perform Bharata Natyam choreography.

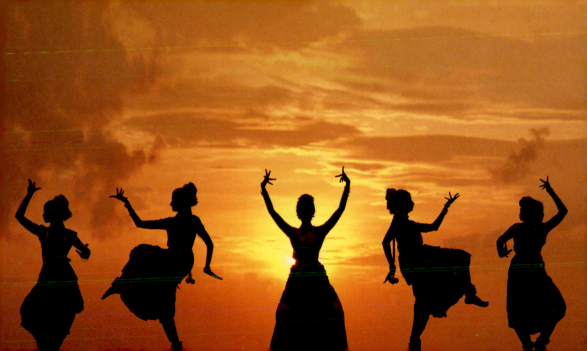

THE ENERGY
OF THE
UNIVERSE

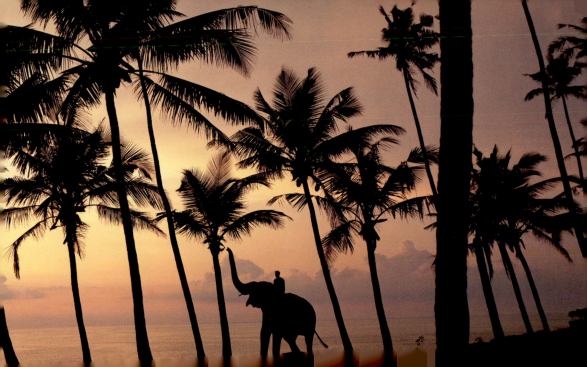

Brahman is as the clay or substance
out of which an infinite variety of articles are fashioned.
As clay, they are all one; but form or manifestation differentiates them.
Before every one of them was made,
they all existed potentially in the clay and of course
they are identical substantially; but when formed, and
so long as the form remains, they are separate and different.

Swami Vivekananda (1863–1902)

Indian village potters make kitchen utensils and religious statues, Rajasthan.

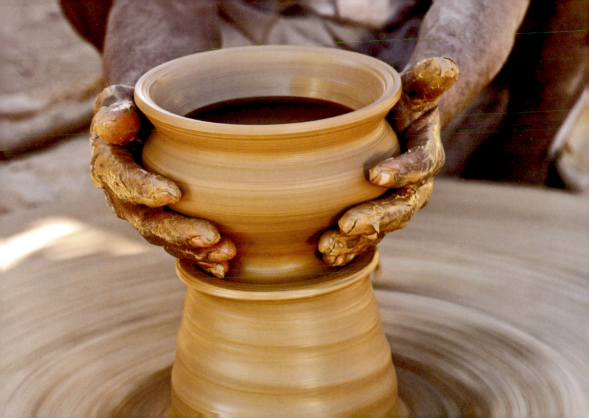

From the soul, one became many;
but in the soul, many are one.

The Mundaka Upanishad (*c.* 800–500 BCE)

Sangeetha, a girl of six, in Tamil Nadu.

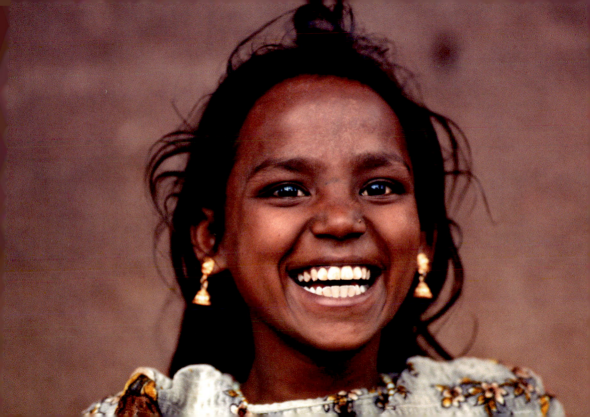

What is the soul?
The soul is consciousness.
It shines as the light within the heart.

The Brihadaranyaka Upanishad (*c.* 800–700 BCE)

The sacred ghats of Varanasi in Uttar Pradesh are thousands of years old.

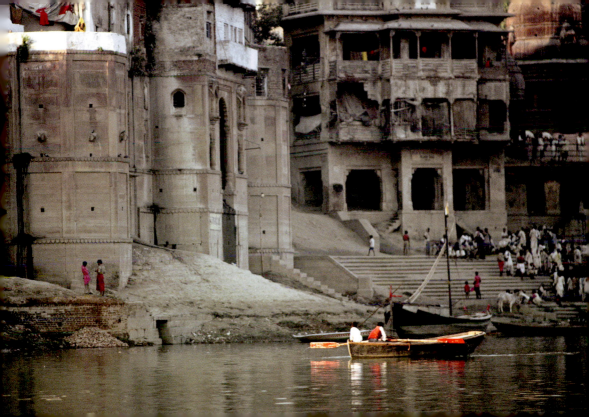

If you see the soul in every living being, you see truly.
If you see immortality in the heart of every mortal being, you see truly.

The Bhagavad Gita (*c.* 400–300 BCE)

Sharifa, a young woman from the semi-nomadic Mir community in Gujarat.

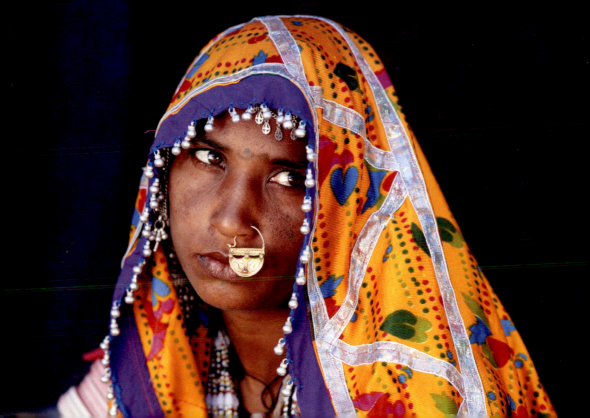

Order is the very essence of the universe –
the order of birth and death and so on.
It is only man that seems to live in disorder, confusion.
He has lived that way since the world began.

Krishnamurti (1895–1986)

India possesses some of the richest biodiversity in the world.

The universe is not ruled by arbitrary, temporary martial law....
Waves rise, each to its own level, with an apparent attitude of relentless rivalry,
but only up to a certain point. We can thus understand the vast serenity
of the sea, to which all the waves are connected, and to which
they must all subside in the rhythm of marvelous beauty.

Rabindranath Tagore (1861–1941)

Khuri oasis in Rajasthan.

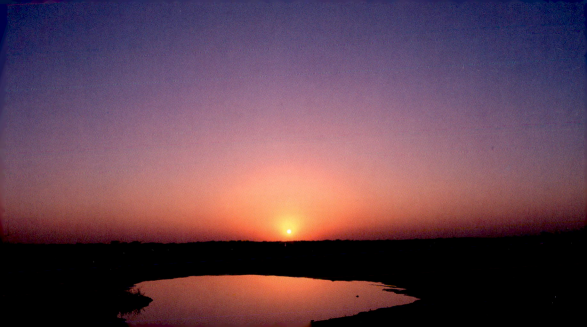

There is an orderliness in the universe,
there is an unalterable law governing everything
and every being that exists or lives.

Mahatma Gandhi (1869–1948)

Daily life on the ghats of Varanasi by the Ganges, Uttar Pradesh.

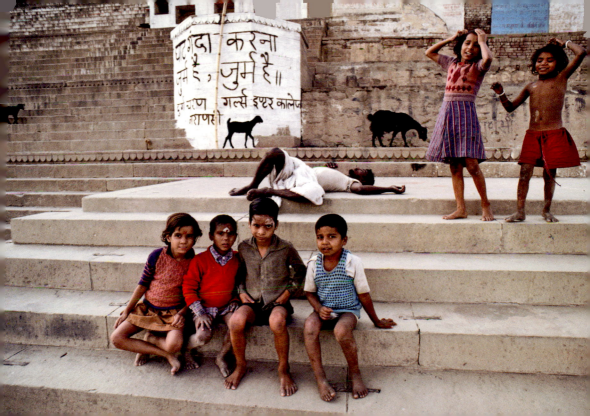

In all religions of the world
you will find it claimed that there is unity within us.
Being one with divinity, there cannot be any further progress in that sense.
Knowledge means finding this unity.

Swami Vivekananda (1863–1902)

Among the young in Rajasthan, clothing is more a question of personal preference than tradition.

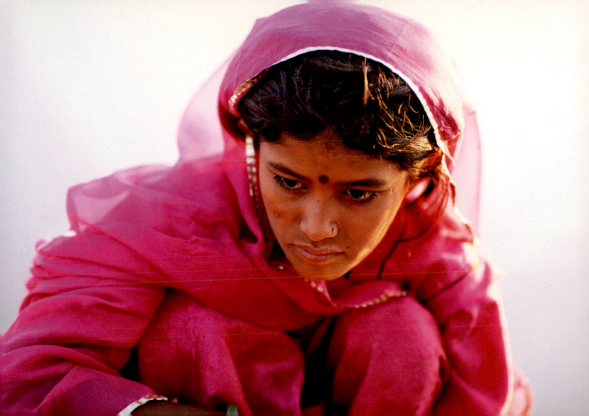

In this world there are two orders of being,
the perishable and the imperishable.
The perishable is all that is visible. The imperishable
is the invisible substance of all that is visible.

The Bhagavad Gita (*c.* 400–300 BCE)

Offering stall next to the temple of Omkareshwar in Madhya Pradesh.

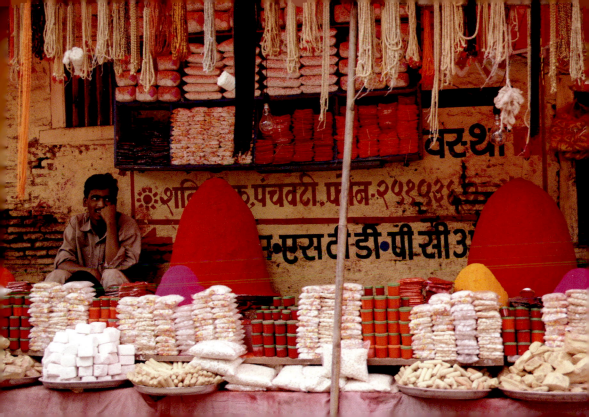

The divine music is incessantly going on within ourselves,
but the loud senses drown the delicate music,
which is unlike and infinitely superior to
anything we can perceive with our senses.

Mahatma Gandhi (1869–1948)

A Rajasthani musician tunes his instrument for a village celebration.

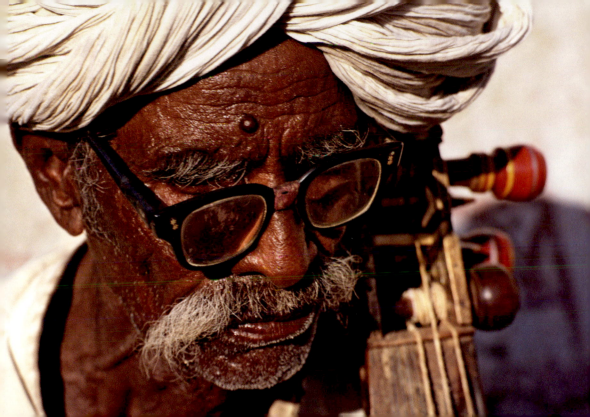

Man has lost his inner perspective,
he measures his greatness by his size
and not by his vital attachment to the infinite;
he judges his activity by his own movement
and not by the serenity of perfection,
not by the peace that exists in the starry vault,
in the rhythmic dance of incessant creation.

Rabindranath Tagore (1861–1941)

The sun sets in the Thar desert, Rajasthan.

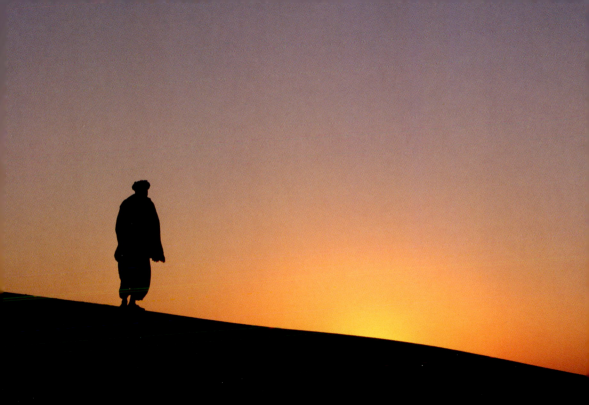

Like the silkworm you have built a
cocoon around yourself. Who will save you?
Burst your own cocoon and come out
as a beautiful butterfly, as a free soul.

Swami Vivekananda (1863–1902)

During the religious feast of Ravechi in Gujarat, a baby sleeps, wrapped in her mother's shawl.

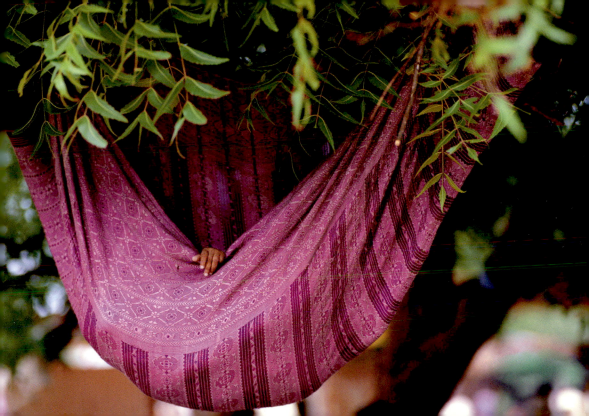

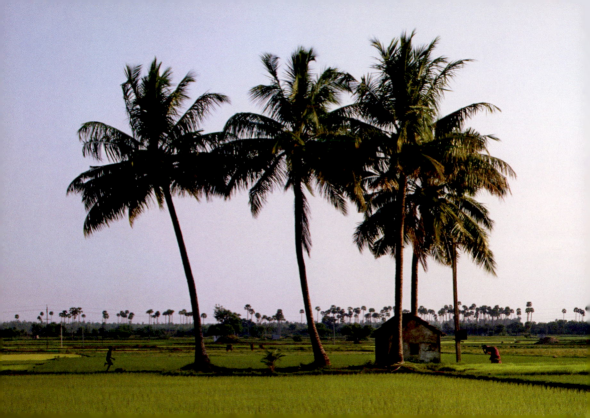

BIRTH & REBIRTH

The energy in the world flows from God at the centre and back to God.
The sages see life as a wheel, with each individual
going round and round through birth and death.
Individuals remain on this wheel so long
as they believe themselves to be separate;
but once they realize their unity with God,
then they break free.

The Shvetashvatara Upanishad (*c.* 400–200 BCE)

Purification in the sacred waters of the Ganges is an important ritual for devout Hindus.

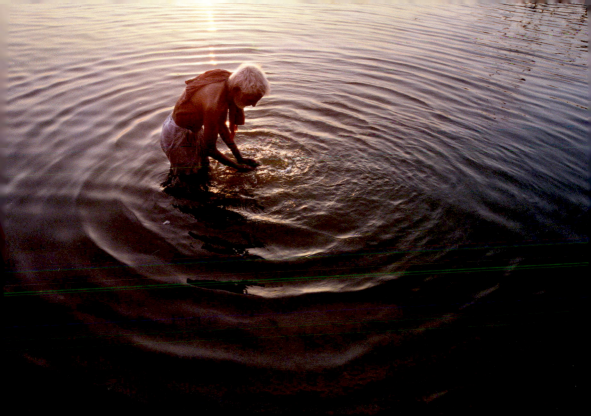

Now why is there any comparison at all?
If you do not compare yourself with another,
you will be what you really are.

Krishnamurti (1895–1986)

Indian women apply the *bindi, chandlo* or *tika* between their eyes as a form of decoration. Gujarat.

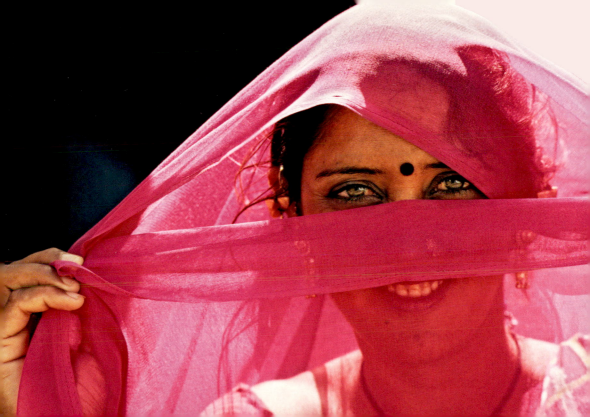

The spiritual can never be attained,
until the material has been extinguished.

Swami Vivekananda (1863–1902)

A *sadhu* (holy man) on a pilgrimage to the temple of Kalaram in Nashik, Maharashtra.

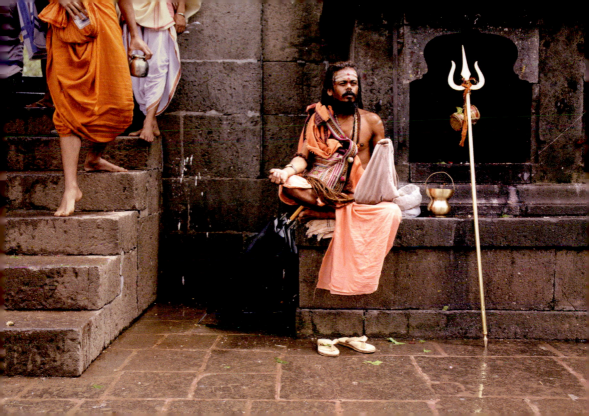

Our responsibility is no longer to acquire, but to be.

Rabindranath Tagore (1861–1941)

A woman on a pilgrimage to the Hindu temple of Ravechi, Gujarat.

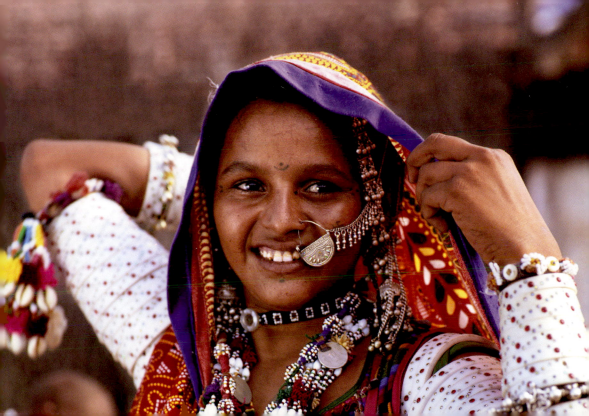

The soul shines in the hearts of all living beings.
When you see the soul in others, you forget your own desires and fears
and lose yourself in the service of others.
The soul shines equally in people on the farthest island,
and in people close at hand.

The Mundaka Upanishad (*c.* 800–500 BCE)

In Gujarat, there are more than sixty cow breeds.

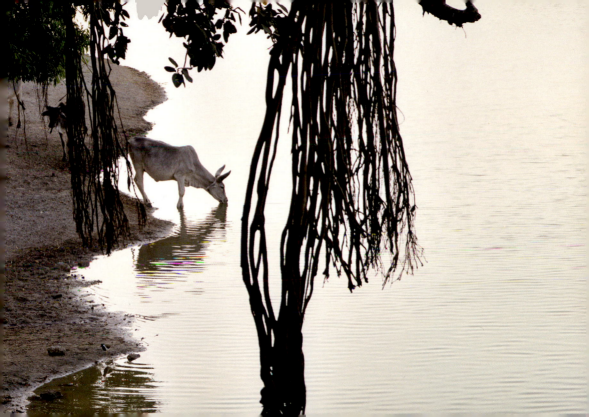

To understand pleasure is not to deny it.
We are not condemning it or saying it is right or wrong
but if we pursue it, let us do so with our eyes open,
knowing that a mind that is all the time seeking pleasure
must inevitably find its shadow in pain.

Krishnamurti (1895–1986)

A moment of modesty for Priyanka, a young girl from Tamil Nadu.

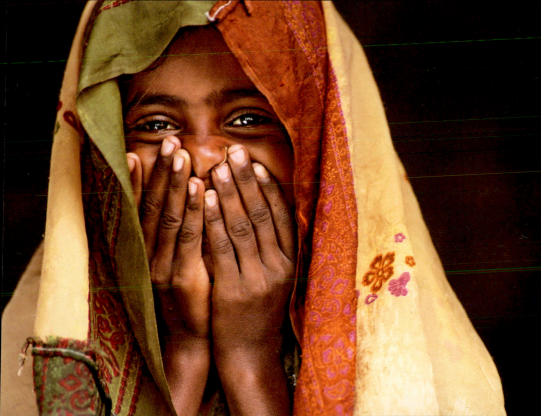

If you wish to release yourself from suffering,
you must first of all release yourself from pleasure.
Then the suffering will disappear.

Swami Prajnanpad (1891–1974)

Shakina, a young girl from the Mir community in Gujarat.

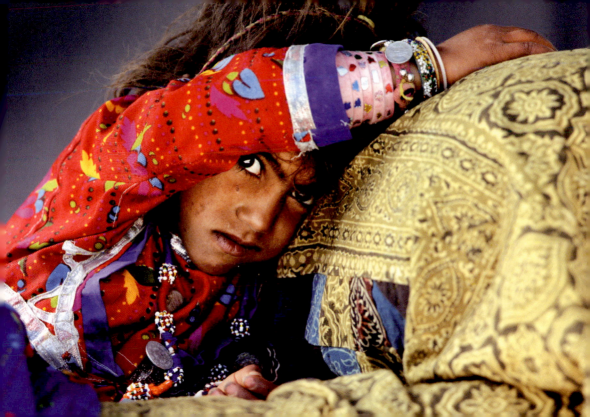

Thought is crooked
because it can invent anything
and see things that are not there.
It can perform the most extraordinary tricks,
therefore it cannot be depended upon.

Krishnamurti (1895–1986)

A rural scene in Madhya Pradesh.

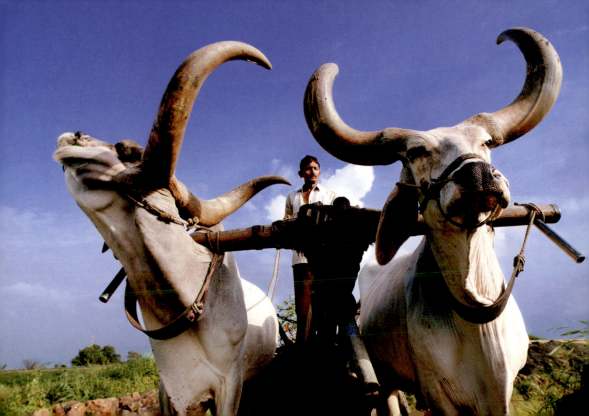

Fear is man's greatest enemy,
and it manifests itself in forms as diverse as
shame, jealousy, anger, insolence, arrogance....
What causes fear? Lack of confidence in oneself.

Swami Prajnanpad (1891–1974)

The woven walls of Adivasi houses protect livestock from wild animal attacks during the night. Madhya Pradesh.

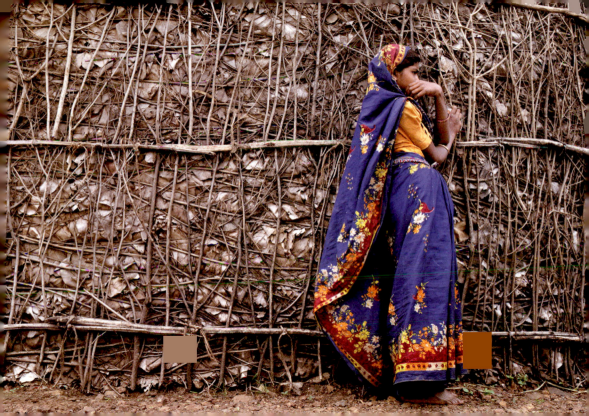

Man falls from the pursuit of the ideal of plain living and high thinking the moment he wants to multiply his daily wants.
Man's happiness really lies in contentment.

Mahatma Gandhi (1869–1948)

The village stalls are a centre for trade and social life alike in Rajasthan.

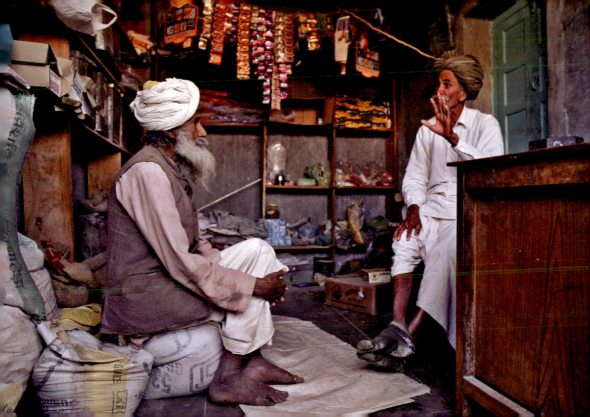

Fear comes from the selfish idea
of cutting one's self off from the universe.

Swami Vivekananda (1863–1902)

Priests pray at sunrise on the Ganges in Varanasi, Uttar Pradesh.

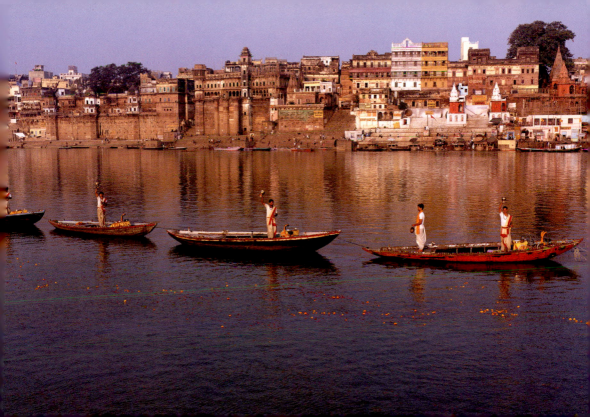

Satisfy one's desires, certainly, but which ones?
And to what extent?
To determine precisely what I want and how.
Children? Money? Glory? How?

Swami Prajnanpad (1891–1974)

Hot tea is often sipped from a saucer to cool it off. Gujarat.

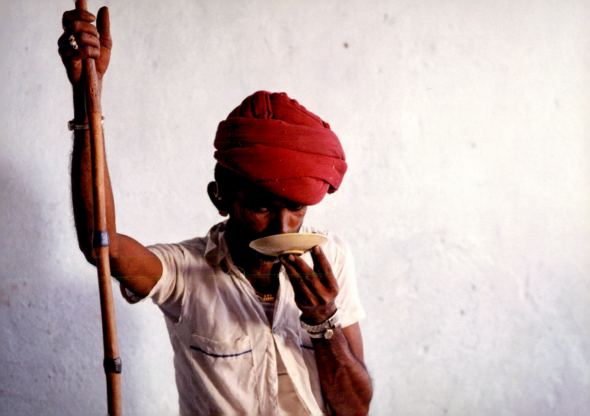

Very few people in this world can reason normally.
There is a terrible tendency to accept all that is said,
all that is read, and to accept it without question.
Only he who is ready to question, to think for himself, will find the truth!
To understand the currents of a river,
he who wishes to know the truth must enter the water.

Nisargadatta Maharaj (1897–1981)

Reflection of the Golden Temple in Amritsar, the Sikhs' most venerated sanctuary.

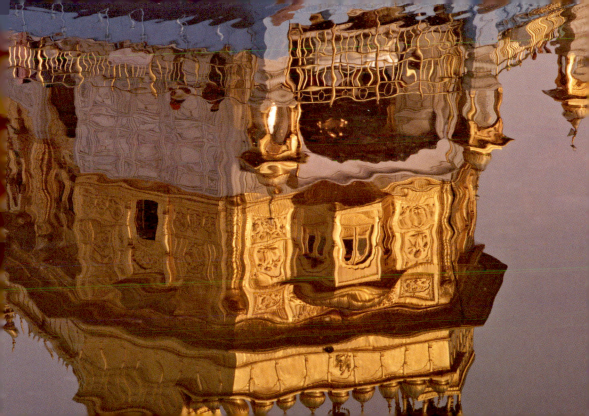

The mind is a vicious circle.
It creates problems for itself
and then tries to resolve them.

Swami Prajnanpad (1891–1974)

A tropical forest in southern India, in the Nilgiri hills, Kerala.

*There is no weapon more powerful in
achieving the truth than acceptance of oneself.*

Swami Prajnanpad (1891–1974)

Indira, a Gujarati farm girl. Before marriage, young women often go unveiled.

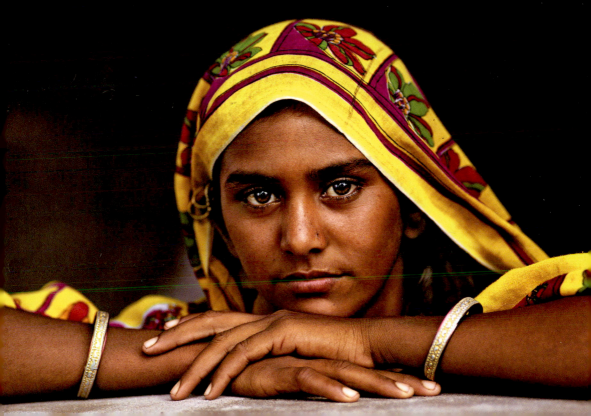

Contemplation is seeing the here and now.

Swami Prajnanpad (1891–1974)

A grandfather in Aravalli, Rajasthan, entertains his grandchildren while ploughing his field.

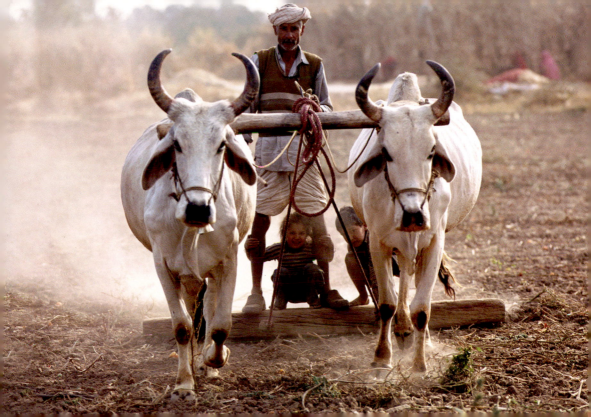

THE THREE YOGAS

The supreme being impregnates all and,
by consequence, is the goodness innate in everything.
To be truly united with all in knowledge, love and service,
and thus to realize the Self in the omnipresent God,
is the essence of good. This is the keystone of the
Upanishad teaching: life is immense.

Rabindranath Tagore (1861–1941)

Pooja, a girl from the village of Verul, Maharashtra, stands outside a temple in the monsoon wind.

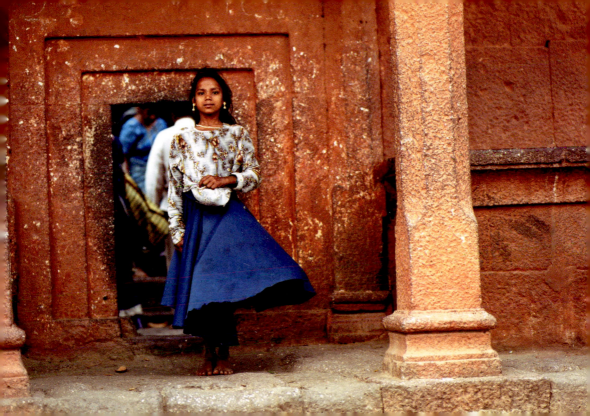

Free yourself from anger and desire, which are the causes of sin and conflict,
and thereby make yourself whole. This is the essence of yoga;
this is the means by which you come to know the soul,
and thereby attain the highest spiritual state. Learn to meditate.
Close your eyes; calm your breathing; and
focus your attention on the centre of consciousness.
Thus you will master the senses, the emotions and the intellect –
and thereby free yourself from desire and anger.

The Bhagavad Gita (*c.* 400–300 BCE)

The symbolic gesture of a young *sadhu* in Vanarasi, Uttar Pradesh.

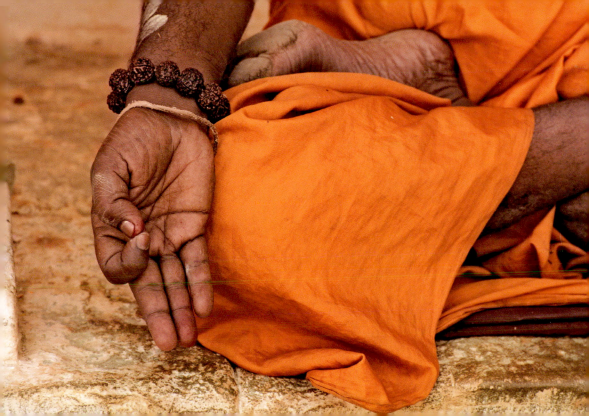

THE YOGA
OF LOVE

What does it matter if we do not understand
the exact meaning of the grand harmony?
Is it not like the bow player who touches a string
and at once releases every resonance?
This is the language of beauty, this is the caress that comes
from the heart of the world and goes straight to our hearts.

Rabindranath Tagore (1861–1941)

This girl has been entrusted with the care of her younger siblings in Jaisalmer, Rajasthan.

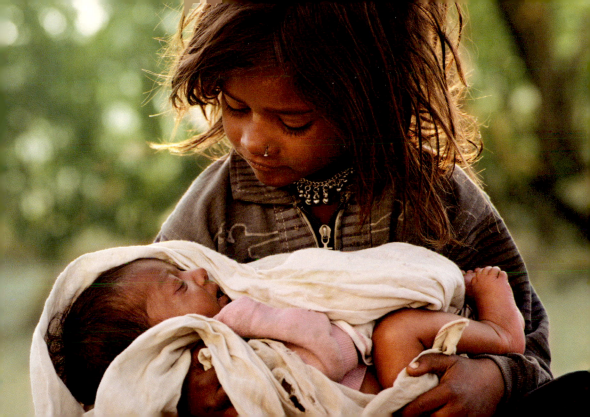

Wherever there is a touch of colour,
a note of a song, grace in a form,
this is a call to our love.

Rabindranath Tagore (1861–1941)

In front of the village mayor, schoolchildren from Khuri celebrate Republic Day, Rajasthan.

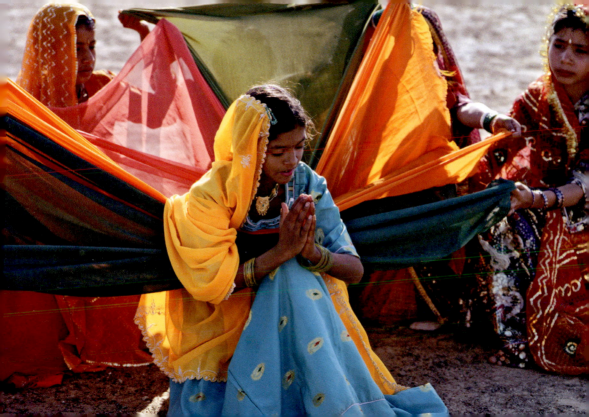

In his essence, man is not a slave to himself, nor to the world; he is a lover.
His freedom and accomplishments are in love,
which is another name for perfect understanding.
In this ability to understand, in this impregnation of everything that is,
he is one with the Spirit that penetrates everything,
and that is also the breath of the soul.

Rabindranath Tagore (1861–1941)

A significant number of Rajasthan villagers emigrate to find work because of the recurring droughts.

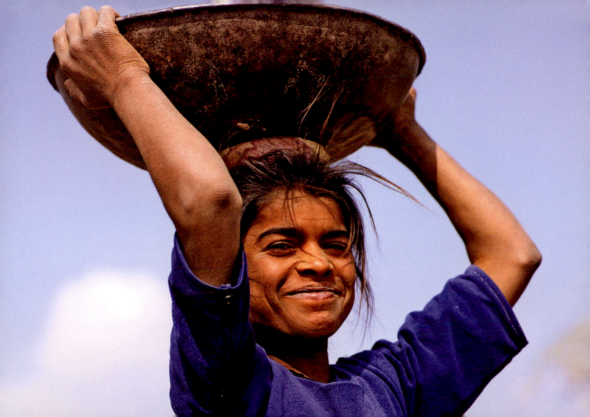

So long as you think you have the least
difference from God, fear will seize you,
but when you have known that you are He,
that there is no difference, entirely no difference,
that you are He, all of Him, and the whole of Him,
all fear ceases. Therefore, dare to be free,
dare to go as far as your thought leads,
and dare to carry that out in your life.

Swami Vivekananda (1863–1902)

Choreography by Pichaya Manet performed at the Jantar Mantar, an 18th-century astronomical observatory in Delhi.

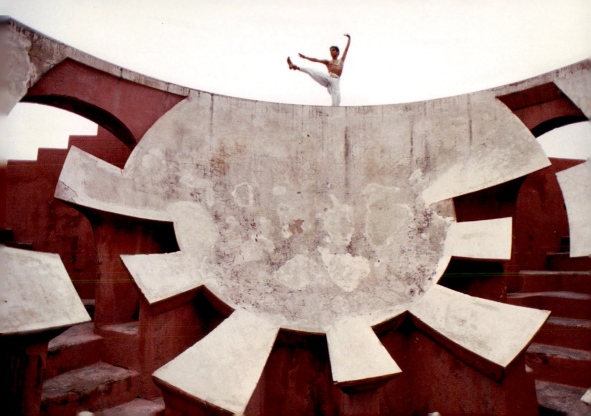

Ever tell yourself, 'I am He.'
These are words that will burn up the dross that is in the mind,
words that will bring out the tremendous energy
which is within you already, the infinite power
which is sleeping in your heart.

Swami Vivekananda (1863–1902)

A child from Verul, Maharashtra.

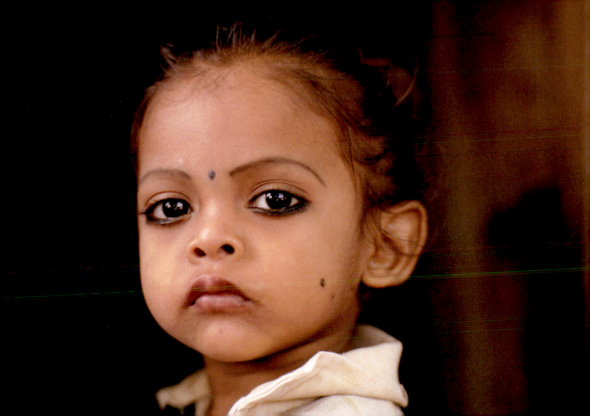

Never say, O Lord, I am a miserable sinner.
Who will help you?
You are the help of the universe.

Swami Vivekananda (1863–1902)

A traditional wrestler from Kerala takes up a yoga position at twilight.

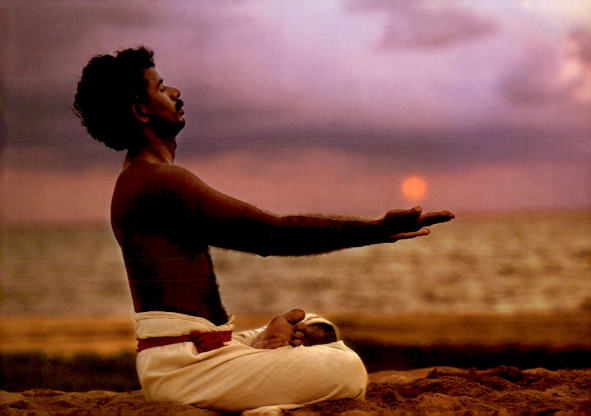

The universal power that manifests itself in the universal law
is at one with our true power.

Rabindranath Tagore (1861–1941)

In the Aravalli mountains of Rajasthan, village women grind corn to make flat cakes.

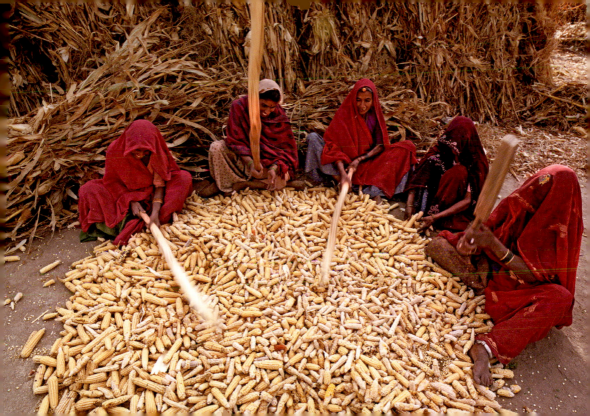

Even at the gate of death, in the greatest danger,
in the thick of the battlefield,
at the bottom of the ocean,
on the tops of the highest mountains,
in the thickest of the forest, tell yourself,
'I am He, I am He.'

Swami Vivekananda (1863–1902)

In the Thar desert of Rajasthan, daily life is dictated by the heat.

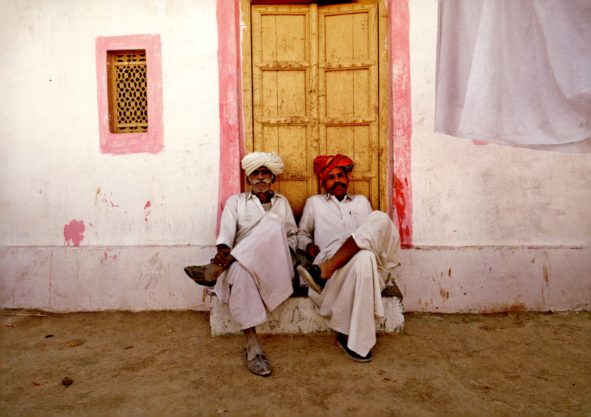

It is through you that the sun shines
and the stars shed their lustre,
and the earth becomes beautiful.
It is through your blessedness that
they all love and are attracted to each other.
You are in all, and you are all.

Swami Vivekananda (1863–1902)

Prayers at sunrise in Varanasi, Uttar Pradesh.

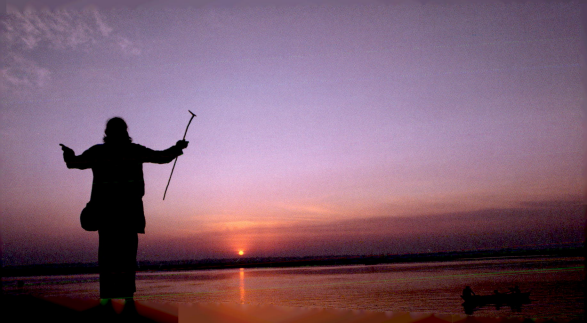

When there is space between you and the object you are observing,
you well know there is no love, and without love,
however hard you try to reform the world
or bring about a new social order or
however much you talk about improvements,
you will only create agony. So it is up to you.

Krishnamurti (1895–1986)

Offerings to the Ganges in Mirzapur, Uttar Pradesh.

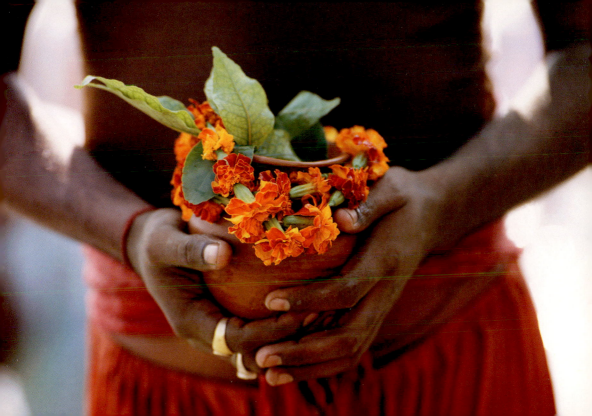

What is it exactly that hurts you?
Open your heart and speak. Open your eyes and see.
At the moment that you look with your eyes wide open,
everywhere you will find differences, an infinite variety.

Swami Prajnanpad (1891–1974)

Isolated in the Himalayas, the tranquil Hunza valley has remained protected for centuries.

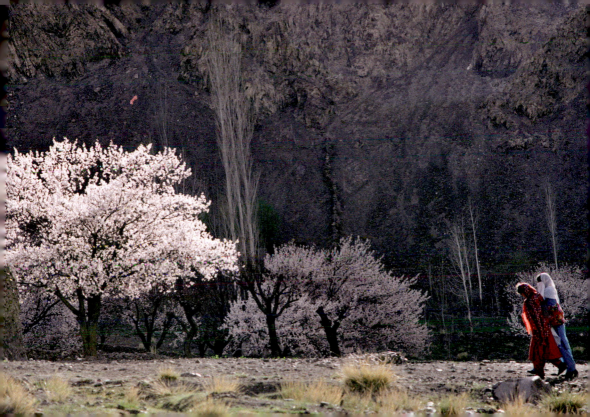

To love is to understand and feel
that the other person is different.

Swami Prajnanpad (1891–1974)

Akash and his father Kulash in Verul, Maharashtra.

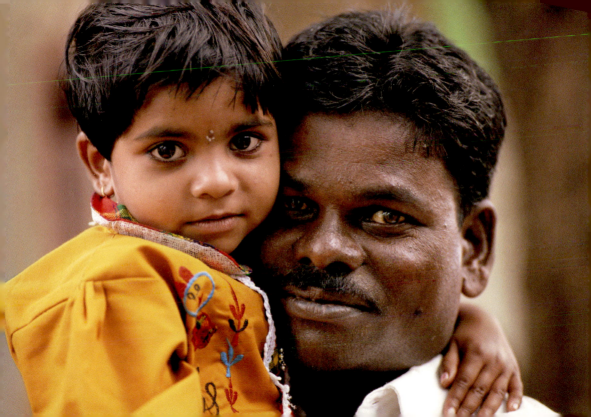

The intellectual aspect is that love sees and understands.
The emotional aspect is to feel as one with the other person.
Love is unity. There is no 'me' in love, only 'you'.
The behavioral aspect is that love inspires us to give.
There is no expectation; we do not expect to receive.
Such love is wisdom and liberation in itself.

Swami Prajnanpad (1891–1974)

A young mother and her child at the Sonepur Mela, Bihar.

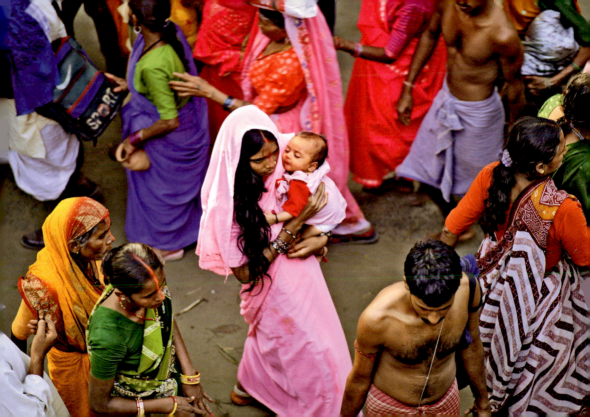

It is only a mind that looks at a tree
or the stars or the sparkling waters of a river
with complete abandonment that knows what beauty is,
and when we are actually seeing, we are in a state of love.

Krishnamurti (1895–1986)

The villagers of Khuri, Rajasthan, meet at the pond to draw water and let their livestock drink.

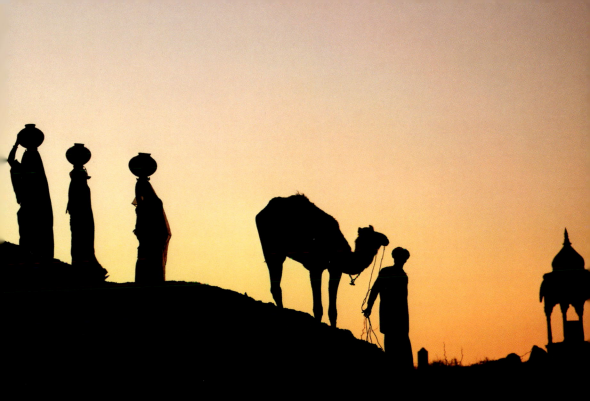

Love implies generosity, care, not to hurt another,
not to make them feel guilty, to be generous, courteous,
and behave in such a manner that your words
and thoughts are born out of compassion.

Krishnamurti (1895–1986)

Maternal uncles play an important role in the family. Gujarat.

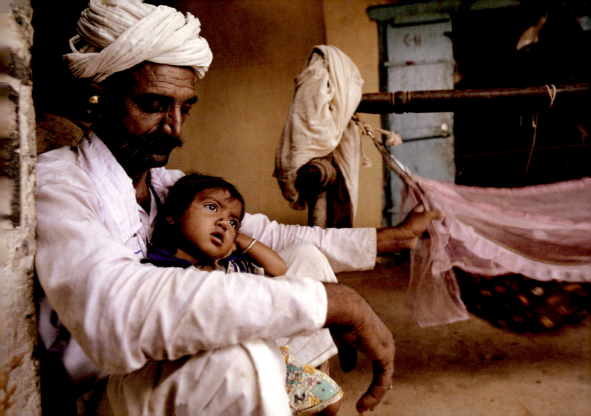

Perceive the souls through the soul and you will become the Supreme Soul....
There are two sides of the consciousness: the soul and the Supreme Soul...
one the seed and the other, entirety. You must have seen
how small the seed of the banyan tree is.
You must also have seen how expansive the tree is.
It is difficult to even imagine that such a small seed can become so big.
The soul is the seed of a banyan tree and the Supreme Soul its development....

Acharya Shri Mahapragya (1920–2010)

Corn grows around the village of Mandu, Madhya Pradesh.

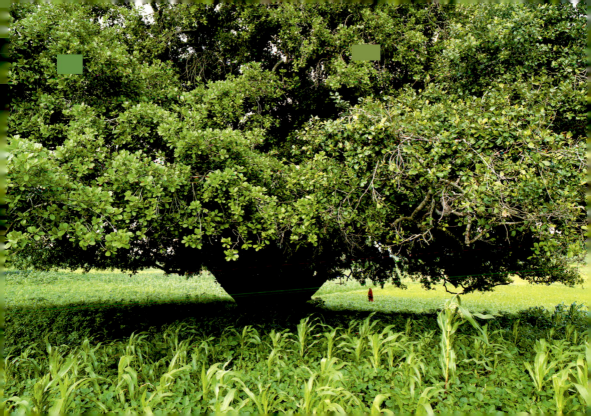

Only the intelligence of love and compassion
can solve all problems of life.

Krishnamurti (1895–1986)

A grandfather and his granddaughter in Gujarat.

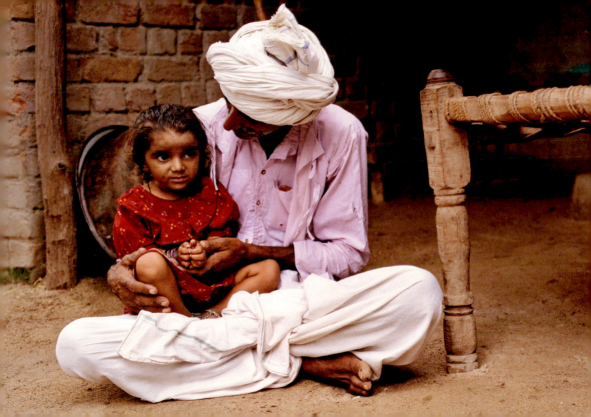

THE YOGA OF KNOWLEDGE

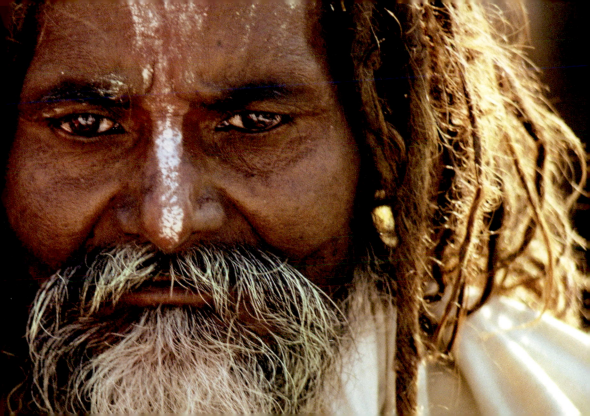

Have you ever tried living with yourself?
If so, you will begin to see that yourself is not a static state,
it is a fresh living thing.
And to live with a living thing, your mind must also be alive.
And it cannot be alive if it is caught in opinions, judgments and values.

Krishnamurti (1895–1986)

Daily exercises among the dairy community of Varanasi, Uttar Pradesh.

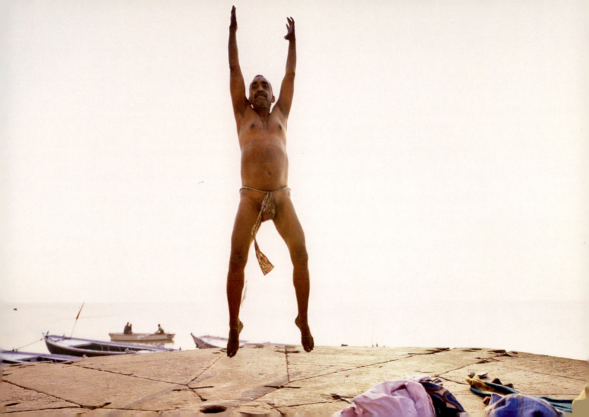

How can we be free to look and learn when our minds
from the moment we are born to the moment we die
are shaped by a particular culture in the narrow pattern of 'me'?
For centuries we have been conditioned by nationality, caste, class, tradition,
religion, language, education, literature, art, custom, convention,
propaganda of all kinds, economic pressure, the food we eat, the climate we live in,
our family, our friends, our experience – every influence you can think of –
and therefore our responses to every problem are conditioned.
Are you aware that you are conditioned?

Krishnamurti (1895-1986)

A young married woman from the semi-nomadic Mir community of Gujarat.

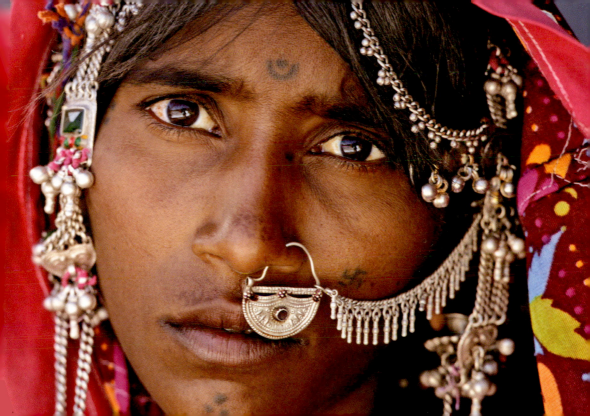

You are the product of your environment.
That is why you are not able to see beyond the habits
and social conventions that are rooted deep within you.
If you wish to see beyond them, you must first of all free yourself
from the normal way in which you interpret facts.

Swami Prajnanpad (1891–1974)

Image of a sacred cow and the deities connected with it, Vanarasi, Uttar Pradesh.

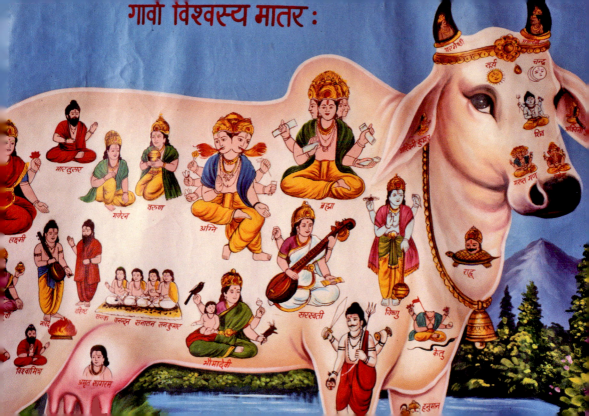

It is not a question of belief.
Stop believing in that which is;
this is what is taught in jnna yoga.
Believe in no other,
stop believing in that which is;
this is the first stage. Dare to be rational.
Dare to follow reason where it may take you.

Swami Vivekananda (1863–1902)

A Gujarati farmer lying on his woven bed after milking his cows.

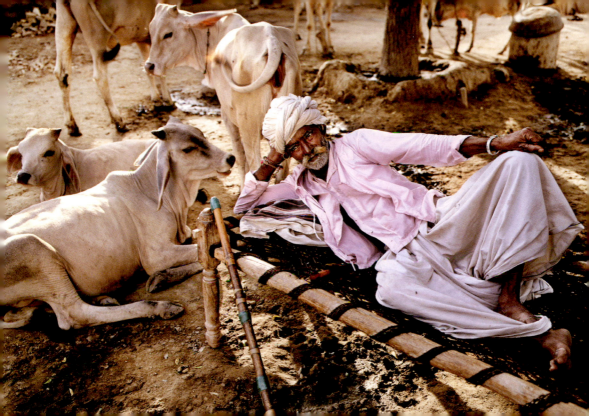

You are unique as you are, here and now.
You are never the same.
You will never be the same again.
You have never before been what you are now.
You will never be it again.

Swami Prajnanpad (1891–1974)

Hansi, a young village woman from Gujarat.

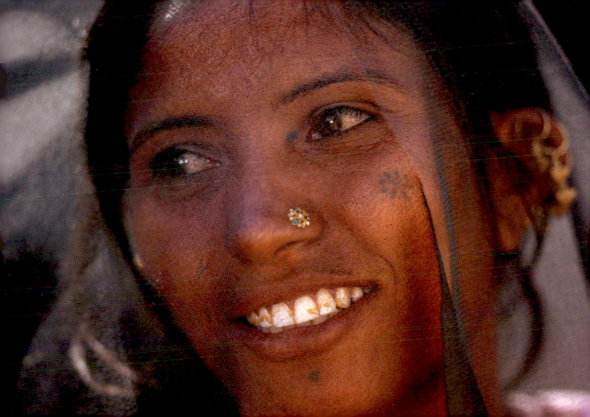

Truth has no path and that is the beauty of truth – it is living.

Krishnamurti (1895–1986)

Daily trips to the well are a chance for village women to meet in Rajasthan.

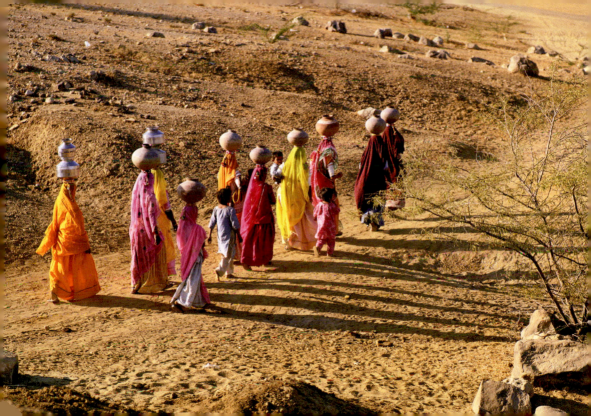

What is change?
One form appears and another disappears.
Can we say that the butterfly used to be a caterpillar?
A substance in the caterpillar takes on the form of the butterfly.

Swami Prajnanpad (1891–1974)

A little girl sleeps in a hammock while her mother gets on with daily chores, Gujarat.

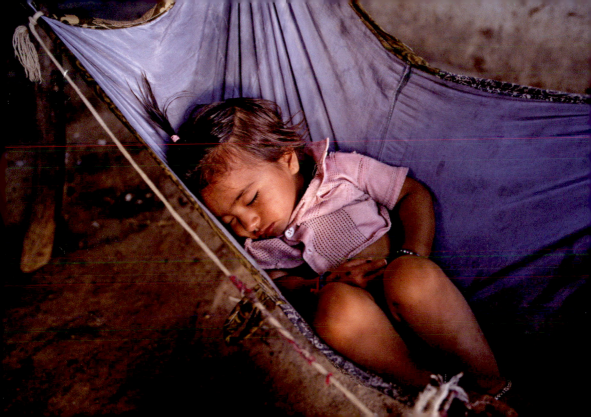

For you, now, meditation involves establishing within yourself
the reality of these two unavoidable rules – difference and change.
Try as hard as possible to convince yourself that
these two rules can neither be changed nor avoided.

Swami Prajnanpad (1891–1974)

Inside the complex surrounding the Golden Temple of Amritsar, the holiest Sikh place of worship.

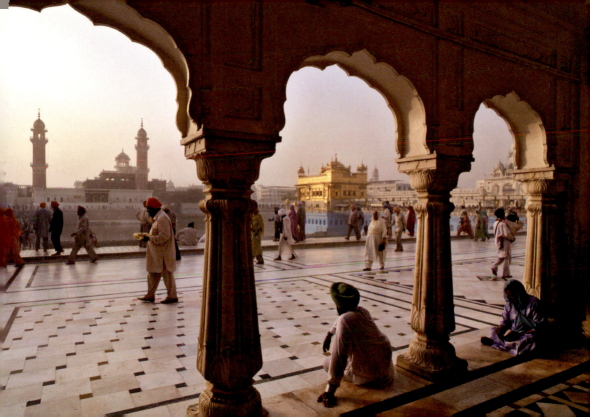

Sensibility is the capacity to feel, recognize,
and distinguish the most tiny and subtle changes.

Swami Prajnanpad (1891–1974)

The foothills of the Kangchenjunga massif, in the north of the state of Sikkim.

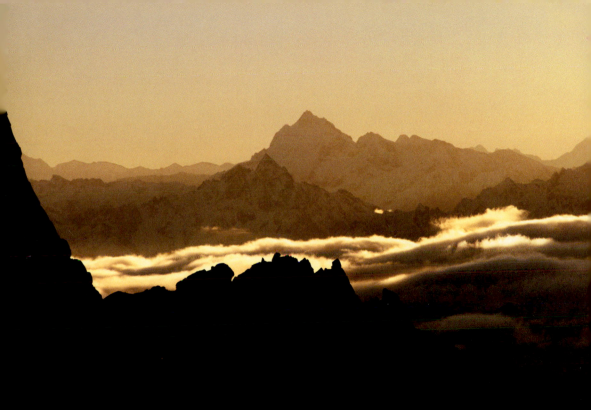

The phrase 'to meditate' does not only mean
to examine, observe, reflect, question, weigh;
it also has, in Sanskrit, a more profound meaning,
which is 'to become'.

Krishnamurti (1895–1986)

Mother and child on a pilgrimage to Ravechi, Gujarat.

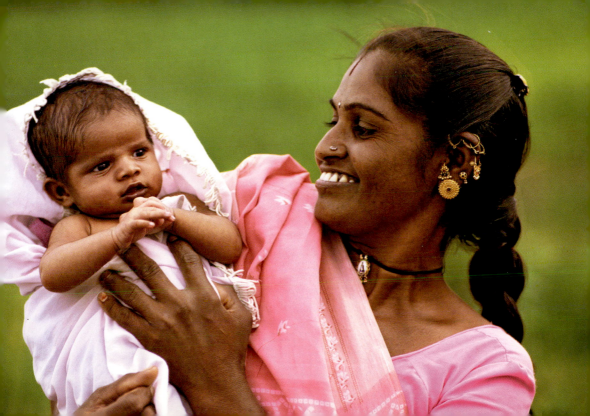

You can live with few clothes or with one meal a day,
but that is not simplicity.
So be simple, don't live in a complicated way,
contradictory and so on, just be simple inwardly.

Krishnamurti (1895–1986)

Dried cow dung is used in many regions as fuel for the cooking fire. Gujarat.

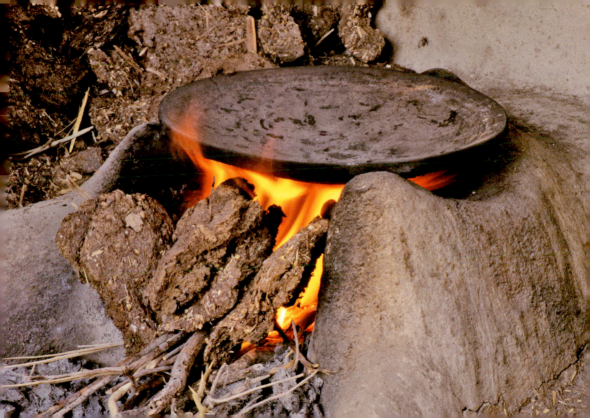

A child must be brought up to understand the word no.
He should be taught yes *first of all,*
then, yes and no, then no *and yes, in such a way*
that he gradually comes to realize that there is really only no.
A child's education is learning to understand no,
and this enables him to grow.
Growing up means accepting the concept of no.

Swami Prajnanpad (1891–1974)

A child whose hair has been shaved off as an offering at the temple of Tirumala, Andhra Pradesh.

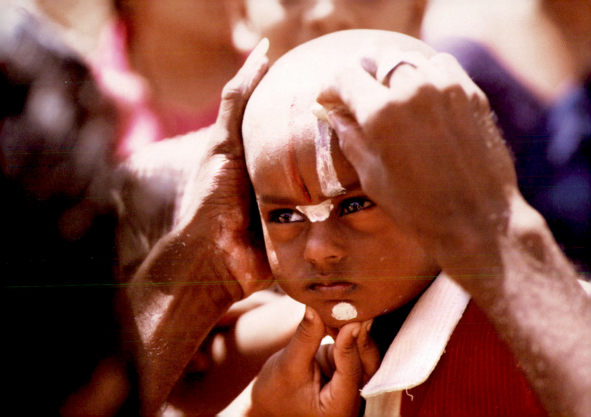

Adaptability is not imitation.
It means power of resistance and assimilation.

Mahatma Gandhi (1869–1948)

The Pushkar camel fair in Rajasthan.

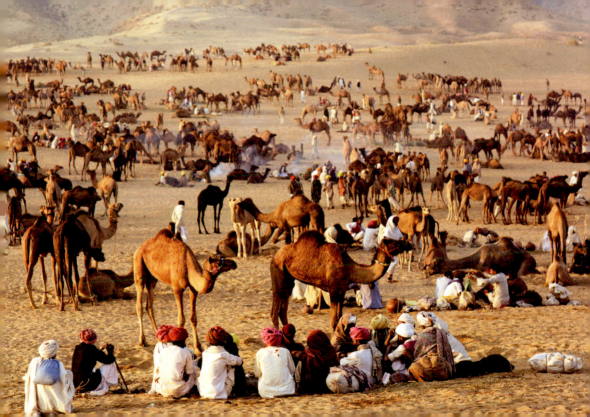

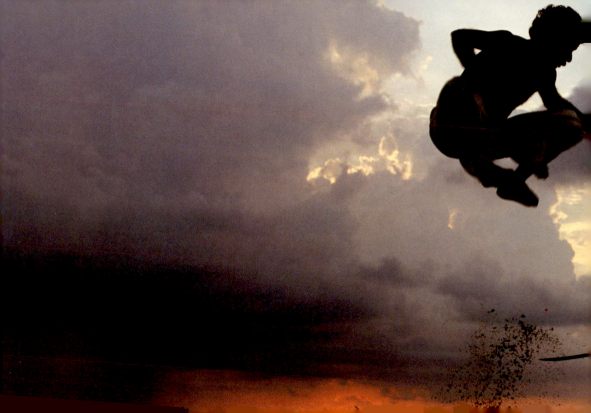

THE YOGA OF
ACTION

That which is immoral is imperfectly moral,
just as that which is false is true to an inadequate degree.

Rabindranath Tagore (1861–1941)

Two porters carry a widow to the summit of the sacred Jain site of Palitana, Gujarat.

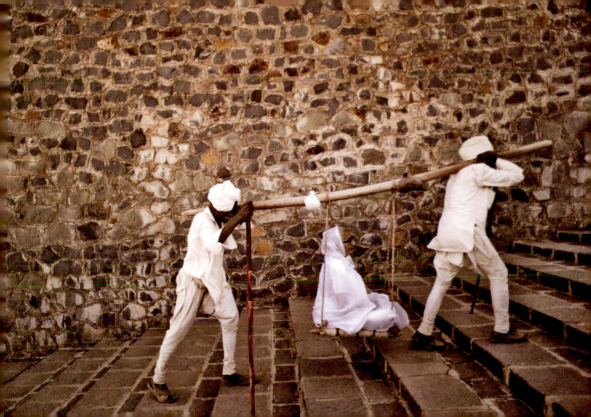

Life is an aspiration. Its mission is to strive after perfection, which is self-fulfillment. The ideal must not be lowered because of our weaknesses or imperfections.

Mahatma Gandhi (1869–1948)

Shanti, a young dancer from Kerala.

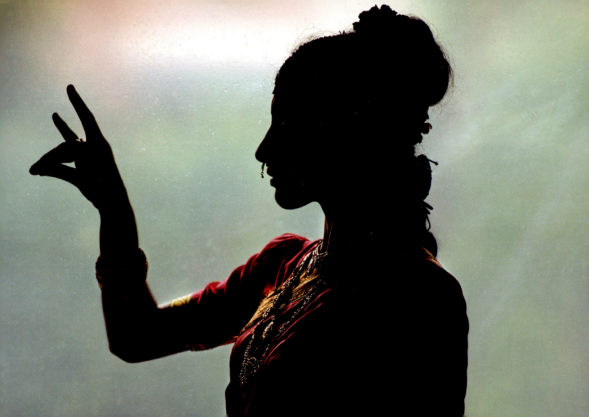

All the responsibility of good and evil is on you.
This is the great hope.
What I have done, that I can undo.

Swami Vivekananda (1863–1902)

A miniature painter in Jodhpur.

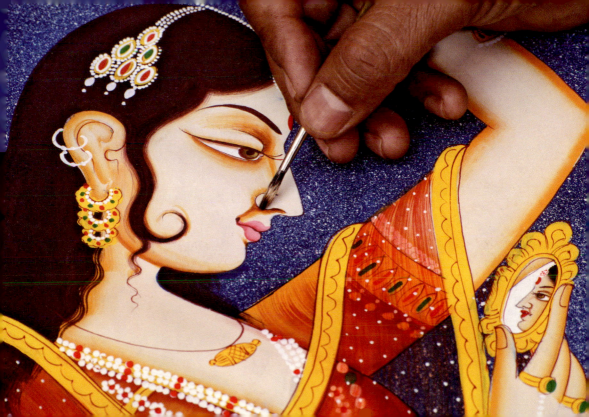

The first condition of humaneness is a little humility
and a little diffidence about the correctness
of one's conduct and a little receptiveness.

Mahatma Gandhi (1869–1948)

An elephant creates a cheerful moment for pilgrims in the temple complex of Tiruchirappalli, Tamil Nadu.

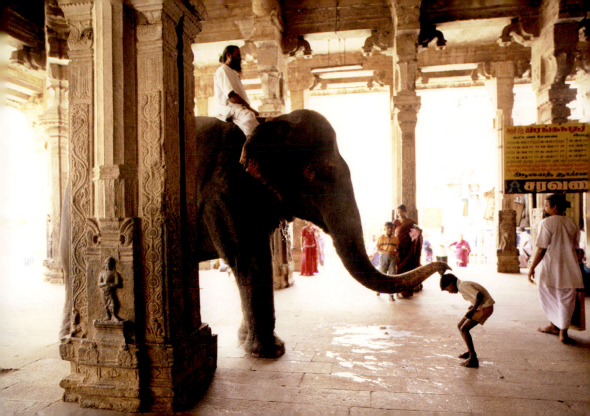

The purity of life is the highest and most authentic art to follow.

Mahatma Gandhi (1869–1948)

Chapati, a flatbread made of wheat or millet, accompanies every meal in northern India. Khuri, Rajasthan.

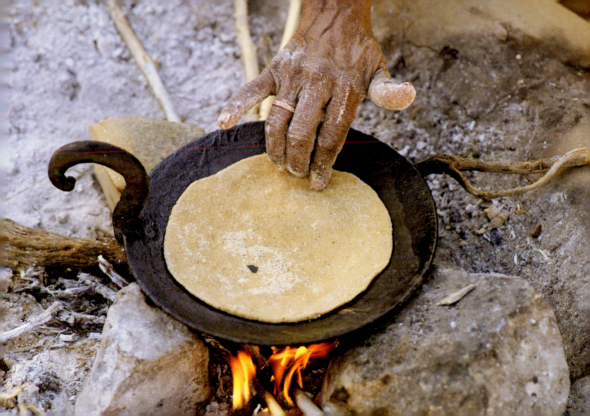

It is necessary that this be the aim of our entire life.
In all of our thoughts and actions,
we must be conscious of the infinite.

Rabindranath Tagore (1861–1941)

The Thar desert in Rajasthan, India's largest but least populous state.

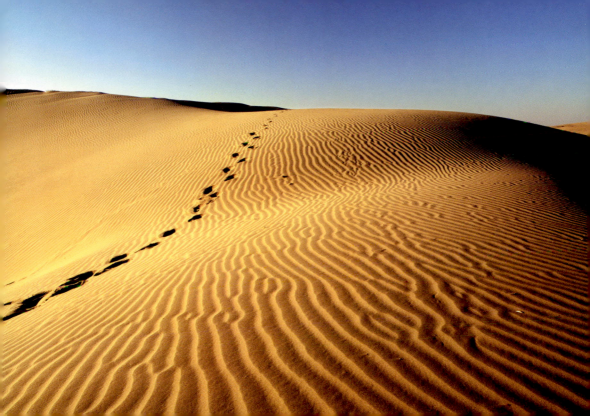

In the search for the truth, for dharma,
real effort does not consist in neglecting action,
but in trying to accord oneself more closely with outer harmony.
The reward of this effort is in becoming:
whatever work you take on, dedicate it to Brahman.

Rabindranath Tagore (1861–1941)

Agriculture remains the largest employer in India. A rural scene from Madhya Pradesh.

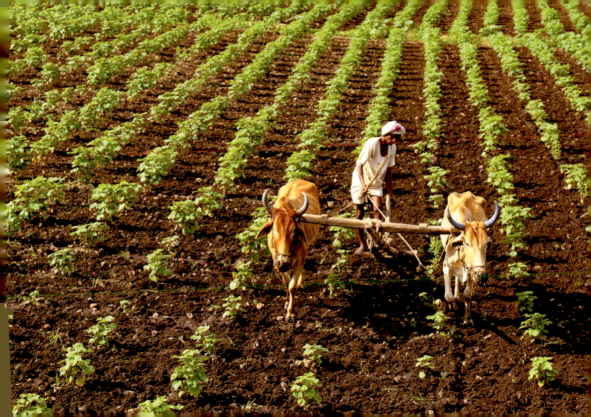

I have always fought not to project but to be myself.
To retain my own scale, which is a dot, but a vibrating dot,
a pulsating dot, that is what I'd like to be.
I would like to remain that pulsating dot which can
reach out to the whole world, to the universe.

Chandralekha (1928–2006)

The Bishnoi community in Rajasthan are vegetarian and strive to protect trees and wildlife.

It is in the very heart of our action that we search for our goal.

Rabindranath Tagore (1861–1941)

A woman from Madhya Pradesh returns to her village with fodder for her goats.

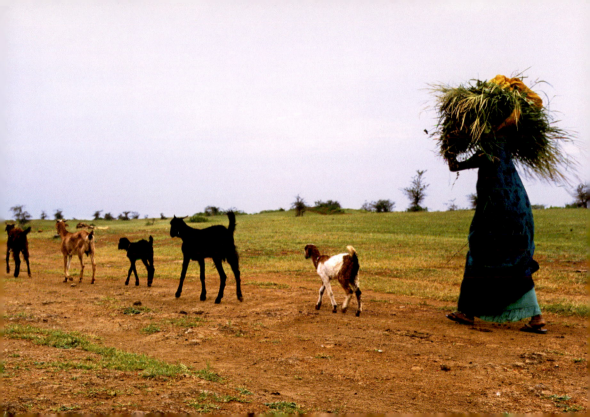

The word duty *indicates compulsion.*
The word responsibility *indicates freedom.*
Duties lead one to demand rightfully.
Responsibilities lead one to command respectfully.
Sense of duty is out of attachment.
Sense of responsibility is out of love.
Duties can be thrust upon others.
Responsibilities are taken up by oneself.
There can be unwillingness in performing one's duty.
Responsibility is always taken up willingly.

Maa Purnananda

To water their animals, the villagers of Thar in Rajasthan mix milk into the water to reduce its saltiness.

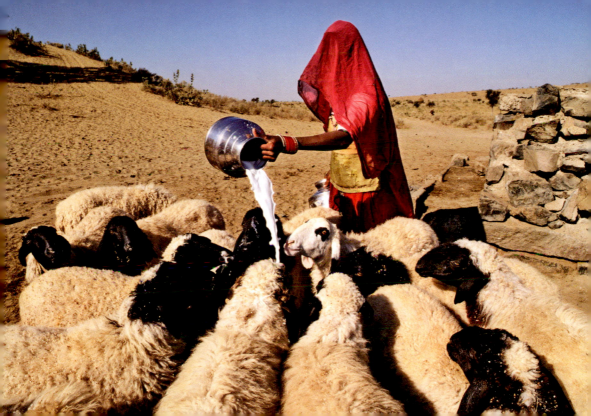

*No matter how insignificant the thing you have to do,
do it as well as you can, give it as much of your care
and attention as you would give to the thing
you regard as most important.*

Mahatma Gandhi (1869–1948)

Before meals, every family makes its own bread. Rajasthan.

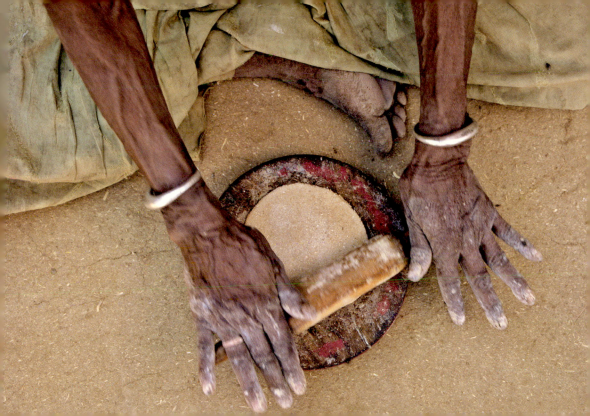

Is there any motion in a straight line?
A straight line infinitely projected becomes a circle,
it returns back to the starting point.
You must end where you begin; and as you began in God,
you must go back to God. What remains? Detail work.
Through eternity you have to do the detail work.

Swami Vivekananda (1863–1902)

A floral arrangement from Tamil Nadu.

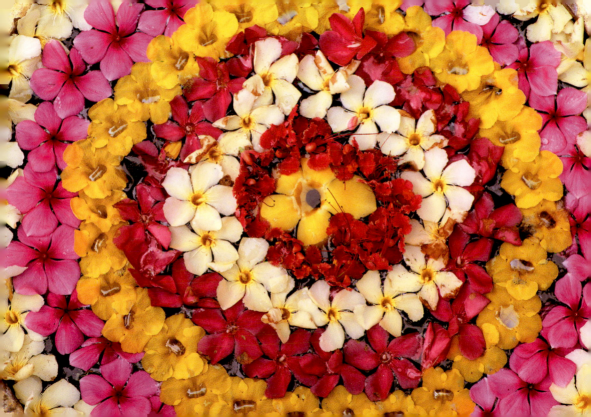

Strength does not come from physical capacity.
It comes from an indomitable will.

Mahatma Gandhi (1869–1948)

The famous balancing rock of Mahabalipuram, Tamil Nadu.

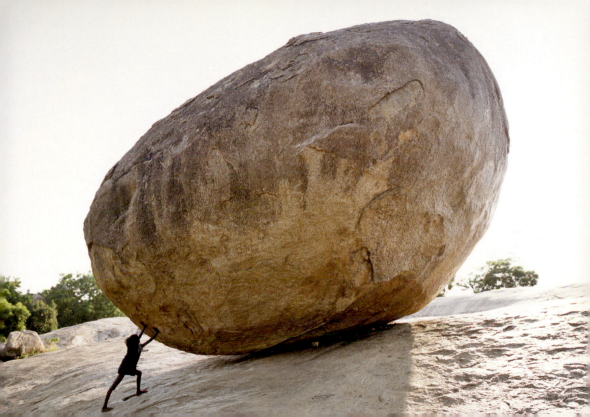

Fearlessness is the first requirement of spirituality.
Cowards can never be moral.

Mahatma Gandhi (1869–1948)

A *sadhu* in Himachal Pradesh.

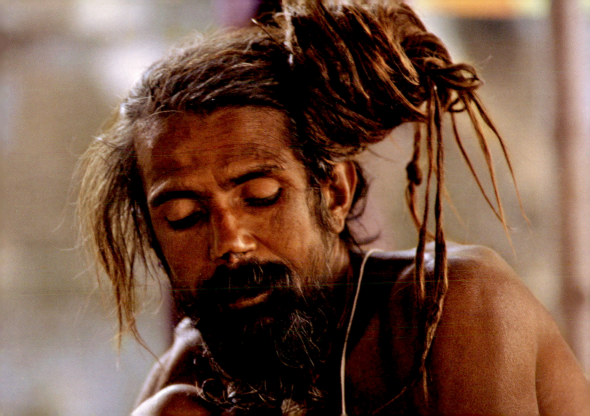

Hold the reins of your mind,
as you would hold the reins of a restive horse.

The Shvetashvatara Upanishad (*c.* 400–200 BCE)

The palaces of Rajasthan have walls decorated with murals.

If by strength is meant moral power,
then woman is immeasurably man's superior.
Has she not greater intuition, is she not more self-sacrificing,
has she not greater powers of endurance,
has she not greater courage? Without her, man could not be.
If nonviolence is the law of our being, the future is with woman.
Who can make a more effective appeal to the heart than woman?

Mahatma Gandhi (1869–1948)

A vermilion mark on the hairline is a symbol that a woman is married. Jodhpur, Rajasthan.

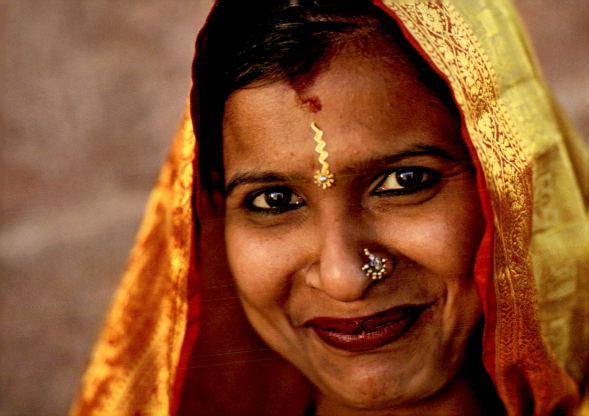

AHIMSA, NONVIOLENCE

Ahimsa means infinite love, which again
means infinite capacity for suffering.
Who but woman, the mother of man,
shows this capacity in the largest measure?

Mahatma Gandhi (1869–1948)

A woman from Rajasthan.

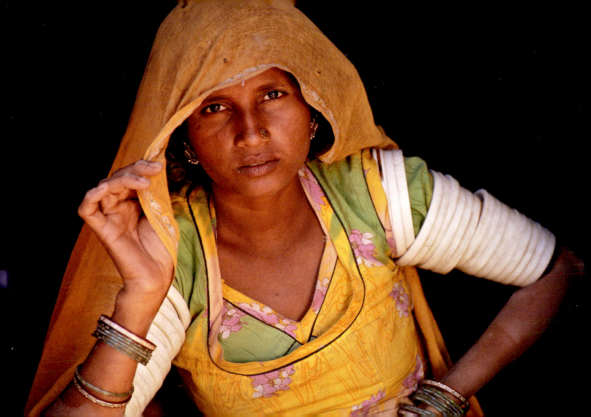

Nonviolence is the summit of bravery.

Mahatma Gandhi (1869–1948)

A young woman from the Adivasi community in the countryside near Mandu, Madhya Pradesh.

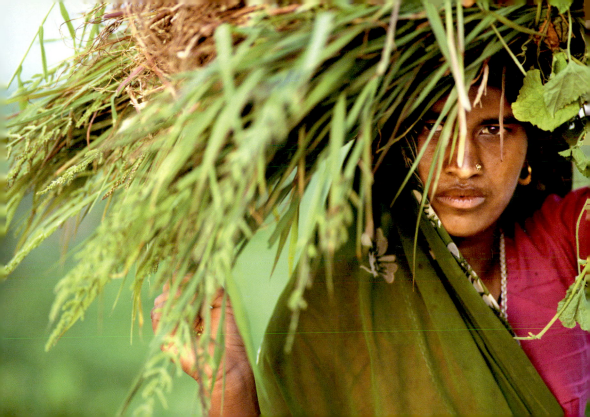

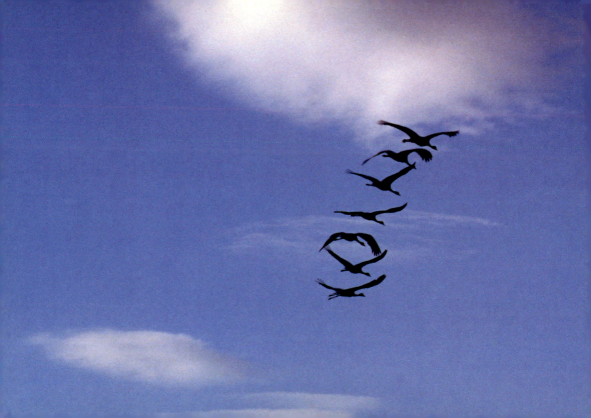

THE ILLUSION
OF DIFFERENCE

Variety is the first principle of life.
What makes us formed beings?
Differentiation.
Perfect balance will be destruction.

Swami Vivekananda (1863–1902)

Pilgrims take a purifying bath during the full moon pilgrimage in Sonepur.

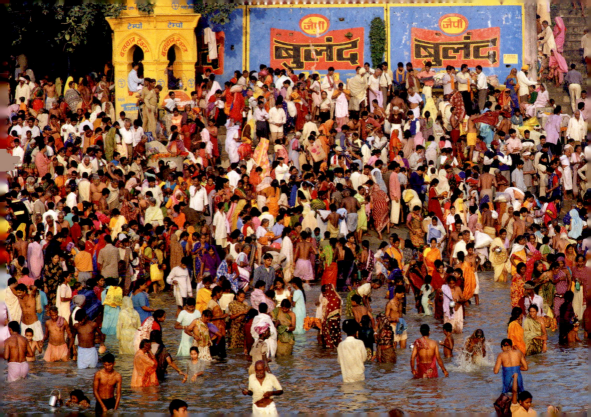

The infinite oneness of the Soul is the eternal sanction of all morality,
that you and I are not only brothers – every literature voicing
man's struggle towards freedom has preached that for you –
but that you and I are really one.
This is the dictate of Indian philosophy.
This oneness is the rationale of all ethics and all spirituality.

Swami Vivekananda (1863–1902)

Morning mists over the Pushkar oasis in the Thar desert, Rajasthan.

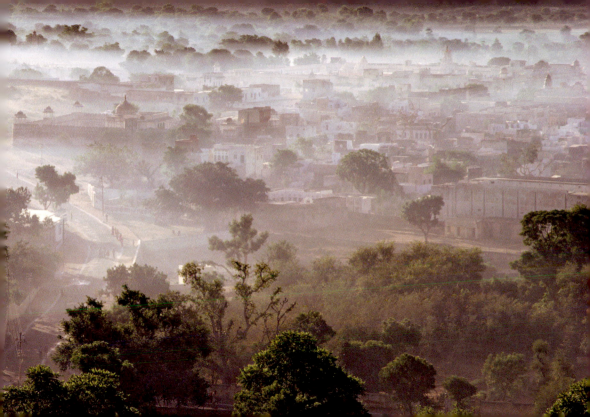

How does seeing the difference permit unity?
Quite simply, because physically speaking there cannot be unity,
since the physical plane consists of shapes,
and all shapes are different.
Unity only exists in the heart. It is a feeling: love.
And in love, the notion of self disappears – only the other remains.

Swami Prajnanpad (1891–1974)

At dusk, peacocks and domestic animals drink from a lake in Ambala, Gujarat.

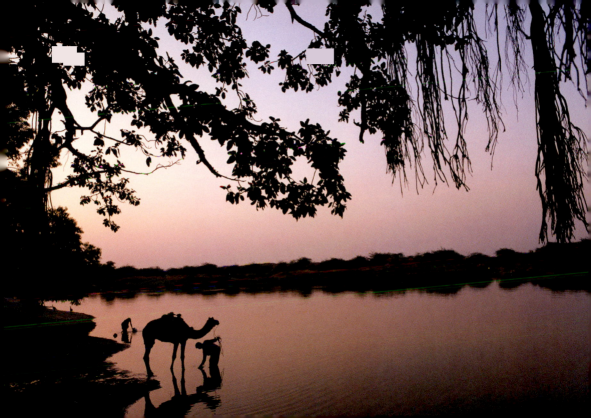

In the song of the rushing torrent,
hold onto the joyful assurance:
I will become the sea.
And this is not a vain supposition;
it is absolute humility, because it is the truth.

Rabindranath Tagore (1861–1941)

After school, children meet at dusk at the pond of Dasada, Gujarat.

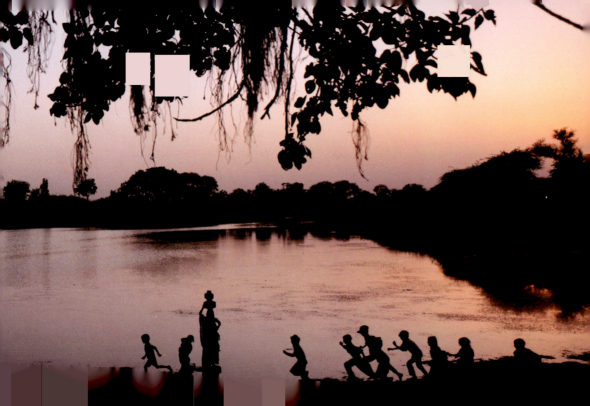

As long as there is division in any form, there must be conflict.
You are responsible, not only to your children,
but to the rest of humanity.
Unless you deeply understand this,
not through words or ideas or the intellect,
but feel this in your blood, in your way of looking at life,
in your actions, you are supporting
organized murder which is called war.

Krishnamurti (1895–1986)

Raghu sits in his mother's arms, deep in thought. Gujarat.

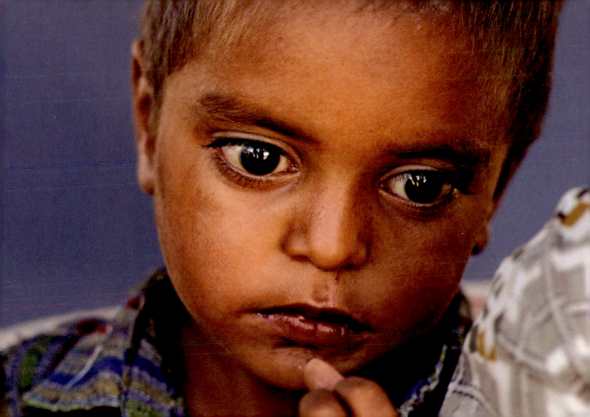

If you do not think he is different,
he is unique, he exists in his own right,
there cannot be any relationship.

Swami Prajnanpad (1891–1974)

Returning from the pond after a hot day, Gujarat.

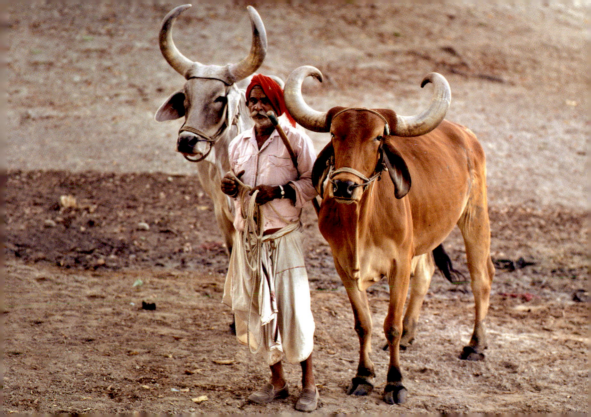

One person is not another person.
What is he, then? He is unique.

Swami Prajnanpad (1891–1974)

These women provide a burst of colour in the arid region of Rajasthan.

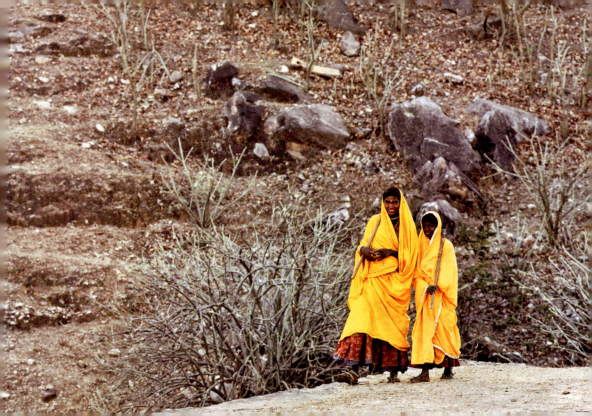

*Knowledge is the annihilation of the
separation between me and the other.*

Swami Prajnanpad (1891–1974)

Pilgrims attending the great religious festival of Kumbh Mela in Nashik, Maharashtra.

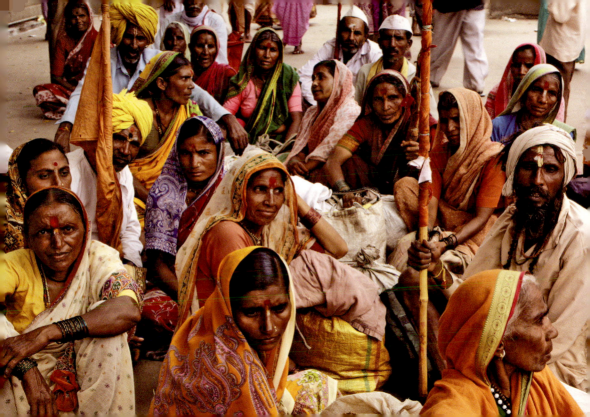

The key to an easy relationship with other people
is not to impose your ego,
nor to crush the ego of others.

Swami Prajnanpad (1891–1974)

The routine of village life allows for moments of relaxation, near Jaisalmer, Rajasthan.

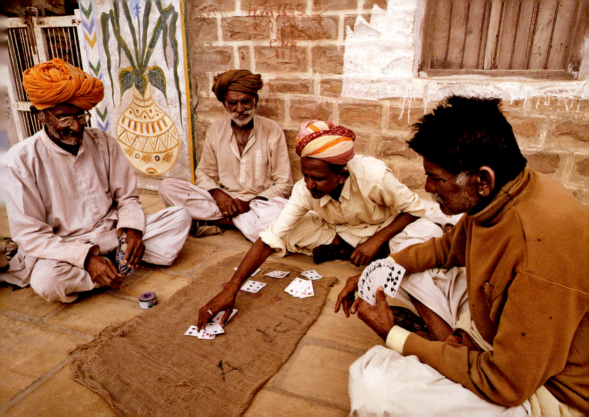

This universe is like an ocean in perfect equilibrium.
A wave cannot rise in one place without creating a hollow elsewhere.
The sum total of the energy of the universe
remains identical from one end to the other.
If you take from one place, you must give elsewhere.

Swami Vivekananda (1863–1902)

Varanasi is one of the world's oldest cities and a sacred site for Hindus, who come to purify themselves in the Ganges.

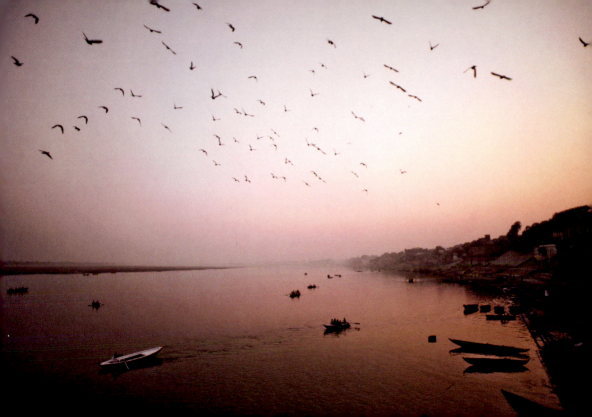

On the inside, everything is connected.
This is because an action in one part produces
a similar reaction elsewhere and thus a response.

Swami Prajnanpad (1891–1974)

A cenotaph of the Maharajahs of Jaisalmer, in the Thar desert, Rajasthan.

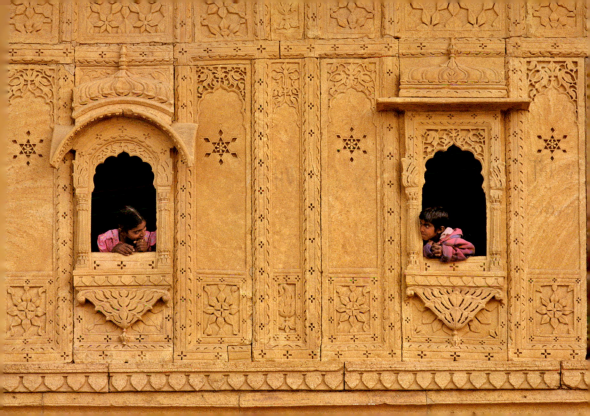

In nature, action and reaction are continuous.
Everything is connected to everything else.
No one part, nothing, is isolated.
Everything is linked and interdependent.

Swami Prajnanpad (1891–1974)

Monsoon clouds in summer against the massifs of the Himalayas, Sikkim.

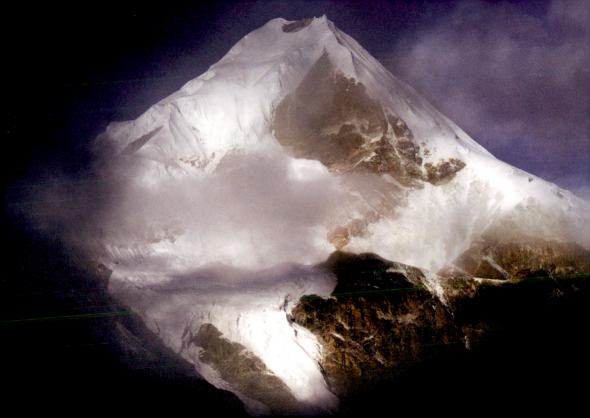

What is the world?
It is the earth below and the sky above –
and the air in space that connects them.
What is light?
It is fire below and the sun above –
and the lightning that connects them.
What is education?
It is the teacher above and the disciple below –
and the wisdom that connects them.

The Taittiriya Upanishad (*c.* 600–500 BCE)

Returning from the well at dusk, Kerala.

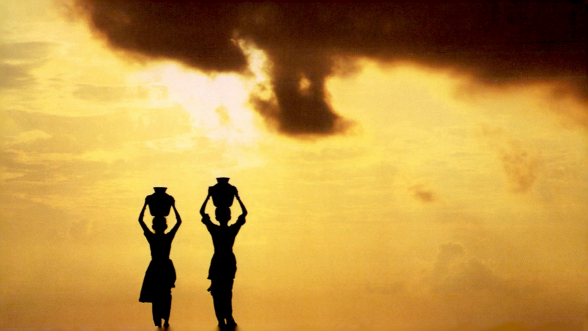

The true source of rights is duty.
If we discharge our duties, rights will not be far to seek.

Mahatma Gandhi (1869–1948)

A policeman helps an old woman across a busy intersection in Varanasi, Uttar Pradesh.

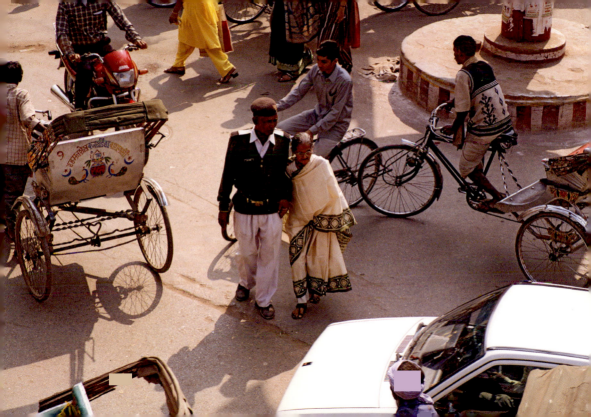

Truth resides in the heart of every man.
And it is there that he must seek it, in order to be guided by it
so that, at the least, it will appear to him.
But we do not have the right to force others
to see the Truth in our way.

Mahatma Gandhi (1869–1948)

In the villages, the end of each day is marked by milking.

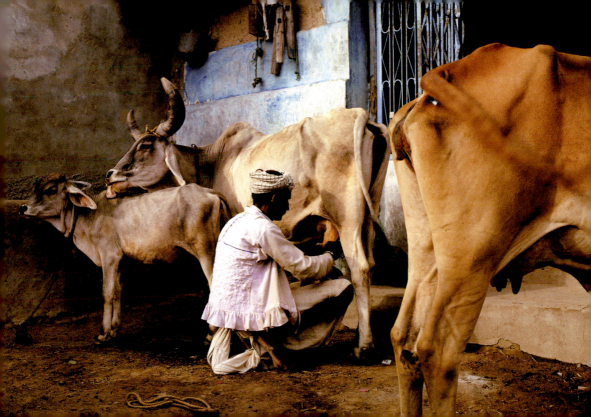

I do not want my house to be walled in on all sides
and my windows to be stuffed.
I want the cultures of all the lands to blow
about my house as freely as possible.
But I refuse to be blown off my feet by any.

Mahatma Gandhi (1869–1948)

After the midday heat has passed, the village square of Ambala, Gujarat, grows lively in the late afternoon.

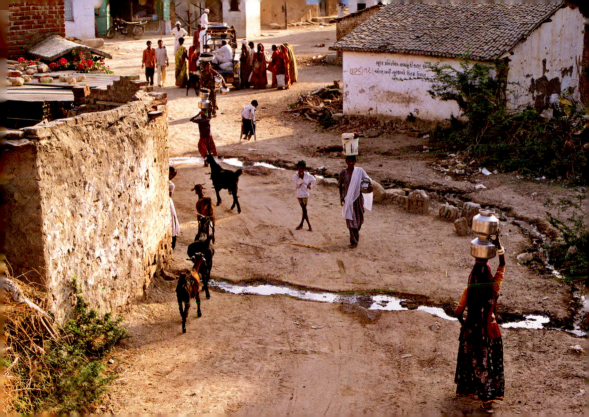

Our contribution to the progress of the world must, therefore, consist of setting our own house in order.

Mahatma Gandhi (1869–1948)

An Adivasi village, a tribal community in Madhya Pradesh.

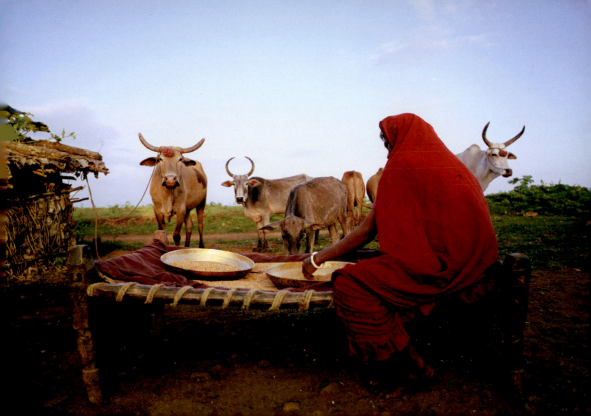

*The sum total of the experience of the sages of the world
is available to us and would be for all time to come.
Moreover, there are not many fundamental truths, but
there is only one fundamental truth which is Truth itself,
otherwise known as nonviolence.*

Mahatma Gandhi (1869–1948)

At the monastic complex of Sanchi, Madhya Pradesh, these relief sculptures date from the second century BCE.

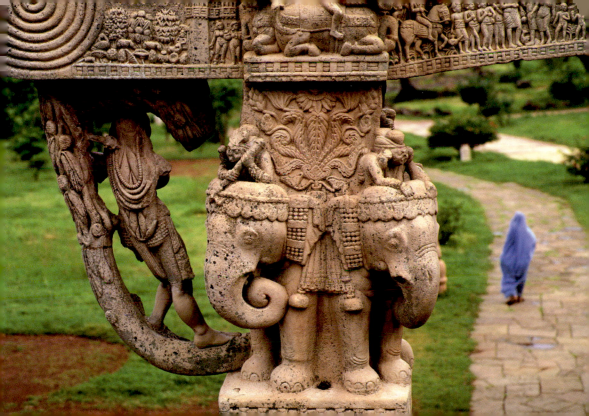

*It is quite proper to resist and attack a system, but
to resist and attack its author is tantamount
to resisting and attacking oneself.
For we are all tarred with the same brush.*

Mahatma Gandhi (1869–1948)

The monkeys at the Jain temple of Ranakpur, Rajasthan, are fed by the Jain community.

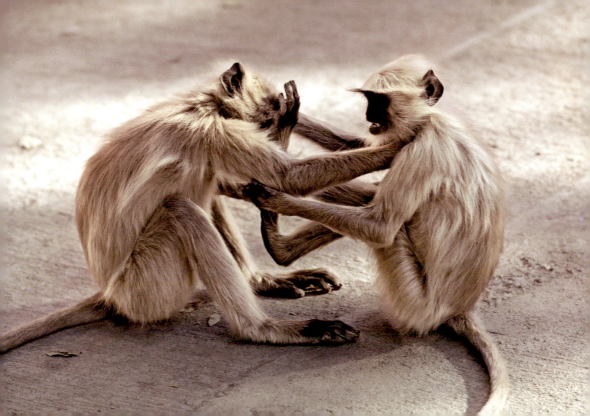

Nonviolence and cowardice go ill together.
I can imagine a fully armed man to be at heart a coward.
Possession of arms implies an element of fear, if not cowardice.
But true nonviolence is impossible without the
possession of unadulterated fearlessness.

Mahatma Gandhi (1869–1948)

While a cow rests, a bird eats insects from its skin. Khuri, Rajasthan.

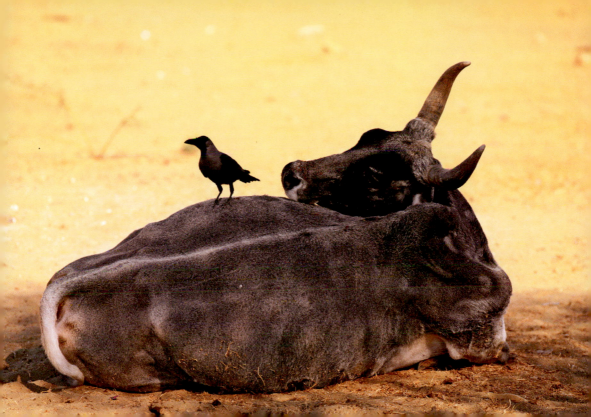

Nonviolence is the greatest force at the disposal of mankind.
It is mightier than the mightiest weapon of destruction
devised by the ingenuity of man.

Mahatma Gandhi (1869–1948)

Offerings to the gods. Gujarat.

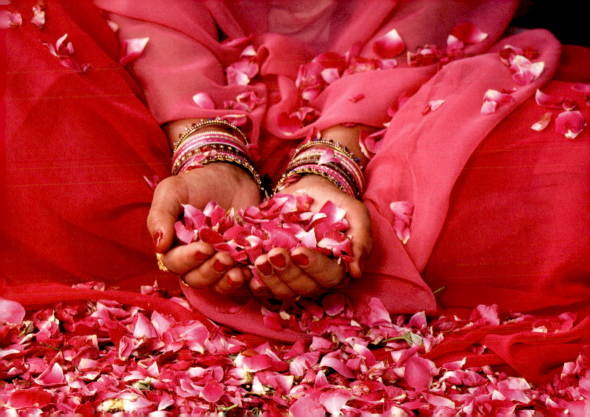

VARIETY &
TOLERANCE

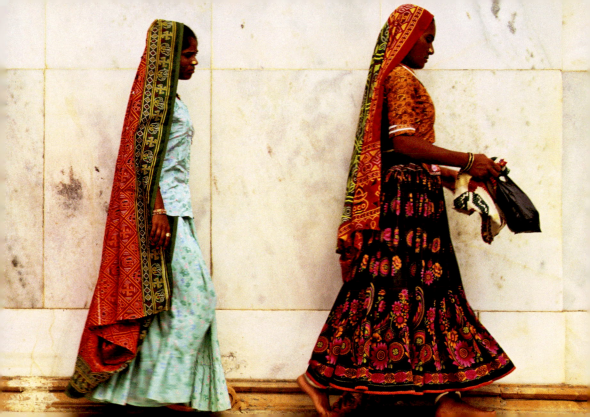

To conquer the subtle passions
seems to me to be far harder than the
physical conquest of the world by the force of arms.

Mahatma Gandhi (1869–1948)

A young *sadhu* on a pilgrimage to Pushkar, Rajasthan.

In your veins, and in mine, there is only one blood,
the same life that animates us all!
Since one unique mother begat us all,
where did we learn to divide ourselves?

Kabir (*c.* 1440–1518)

Prayers in the great mosque of Ahmedabad, under a porch where the many names of the Prophet are written in calligraphy.

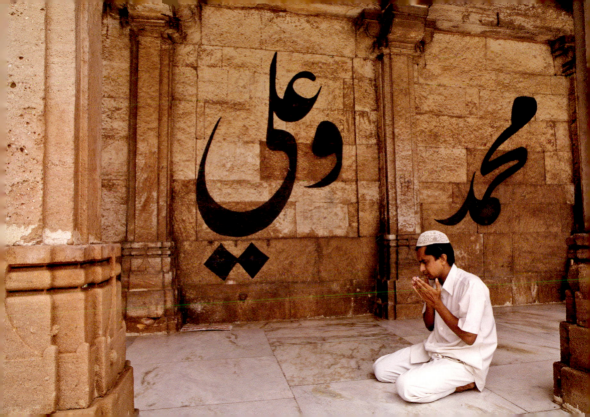

He whom I have searched for has come to meet me,
and he who calls me Other has become me!

Kabir (*c.* 1440–1518)

In Madhya Pradesh, a young shepherdess returns home after watching over her goats all day.

To make a decision is an illusion.
Behind the decision is the hidden belief
that everyone is the same.

Swami Prajnanpad (1891–1974)

After the month of Ramadan, Muslims flock outside the Jama Masjid mosque in Delhi to celebrate the festival of Eid.

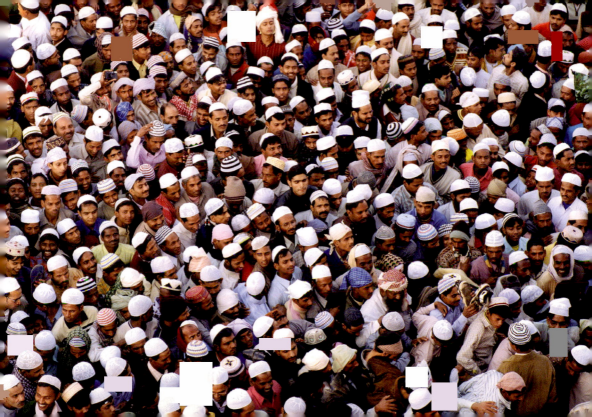

Give with faith and never without faith.
Give with dignity. Give with humility. Give with joy.
And give with understanding of the effects of your gift.

The Taittiriya Upanishad (*c.* 600–500 BCE)

The disease of leprosy can now be effectively treated and is beginning to disappear. Vanarasi, Uttar Pradesh.

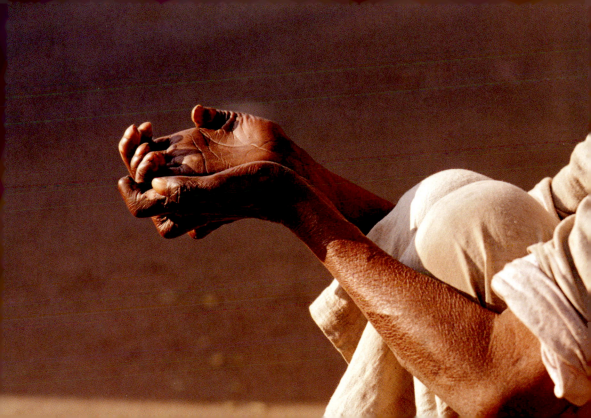

Economic equality is the master key to nonviolent independence.

Mahatma Gandhi (1869–1948)

A farm worker ploughs the field for the landowner.

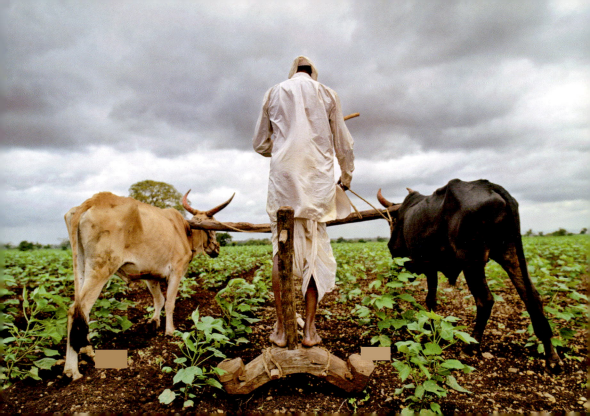

When the poor come to you in great need, begging for food,
do not harden your hearts against them.
Remember that the poor may once have been rich,
and you may one day be poor.
When you see people who are thin for lack of food,
beg them to accept your help;
remember that you may need their friendship in times to come.

The Rig Veda (*c.* 1200 BCE)

A beggar protects himself and his son from the monsoon outside the Haji Ali mosque, Mumbai.

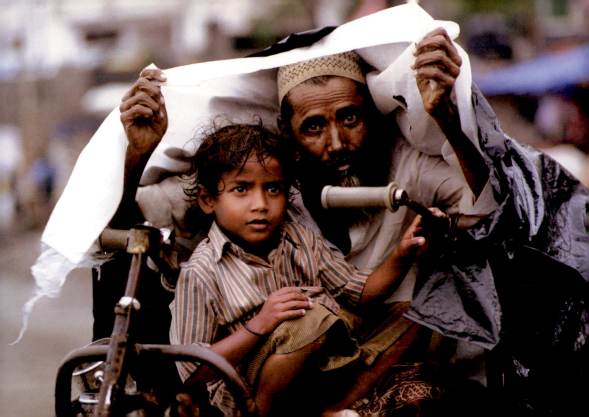

*I must confess that I do not draw a sharp line
or any distinction between economics and ethics.*

Mahatma Gandhi (1869–1948)

The majority of street workers are paid by the task, Tamil Nadu.

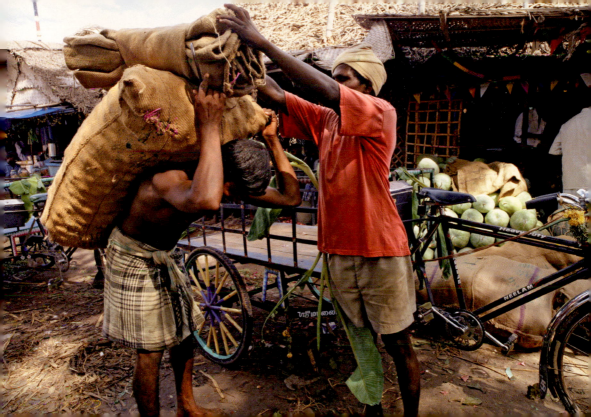

The spirit of democracy
is not a mechanical thing
to be adjusted by abolition of forms.
It requires change of heart.

Mahatma Gandhi (1869–1948)

Abai Kumar, 10 months old, and his father in Sonepur.

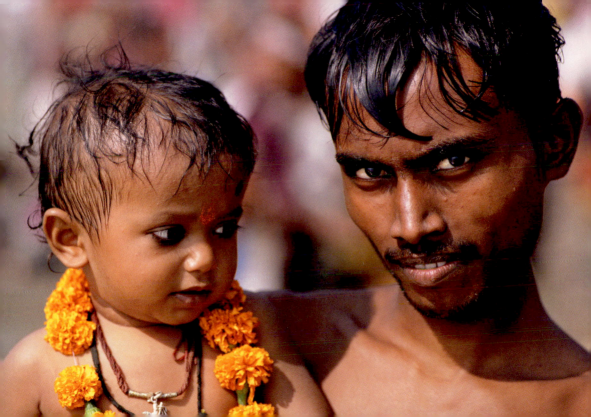

We must learn to love those who think exactly opposite to us.
We have humanity as a background, but each must have
his own individuality and his own thought.
Push the sects forwards and forwards till
each man and woman are sects unto themselves.
We must learn to love the man who differs from us in opinion.
We must learn that differentiation is the life of thought.
We have one common goal and that is the
perfection of the human soul, the god within us.

Swami Vivekananda (1863–1902)

Villagers visit market stalls during the festival of Kangra.

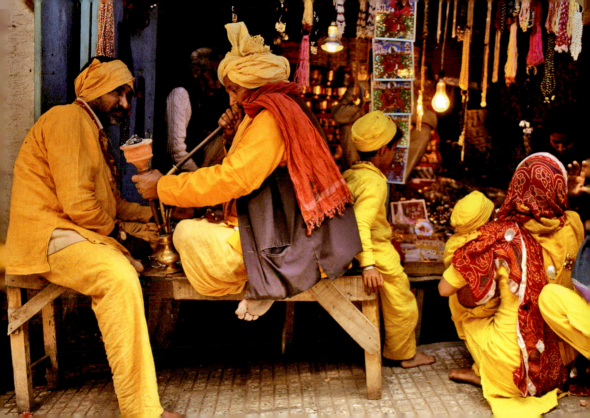

When you call yourself an Indian or a Muslim,
or a Christian, or a European, or anything else,
you are being violent. Do you see why?
Because you are separating yourself from the rest of mankind.
When you separate yourself by belief, by nationality,
by tradition, it breeds violence.

Krishnamurti (1895–1986)

A boat on the Ganges, transporting sand for cement making. Vanarasi, Uttar Pradesh.

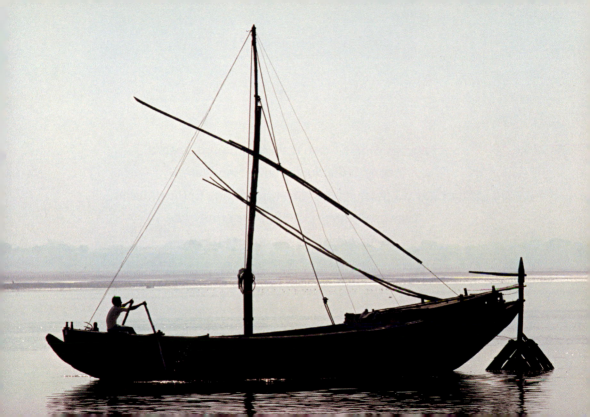

Nations cohere because there is mutual regard
among individuals composing them.
Some day we must extend the national law to the universe,
even as we have extended the family law
to form nations – a larger family.

Mahatma Gandhi (1869–1948)

The blue-painted houses of Jodhpur, Rajasthan.

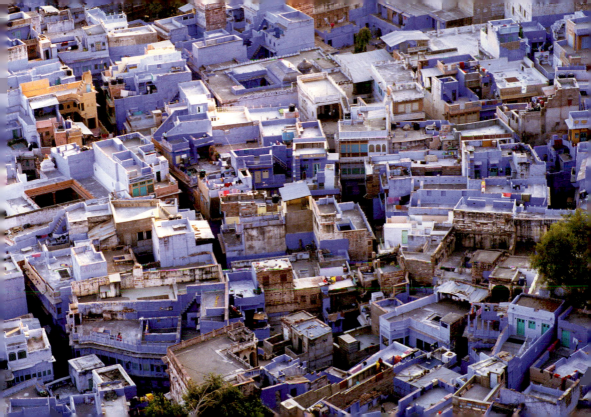

There is one God.
Eternal truth is his name.
He is the maker of all things.
He fears nothing,
and is the enemy of no one.

Guru Nanak (1469–1539)

The Himalayan mountain range in winter with an aerial view of Ladakh towards the southwest.

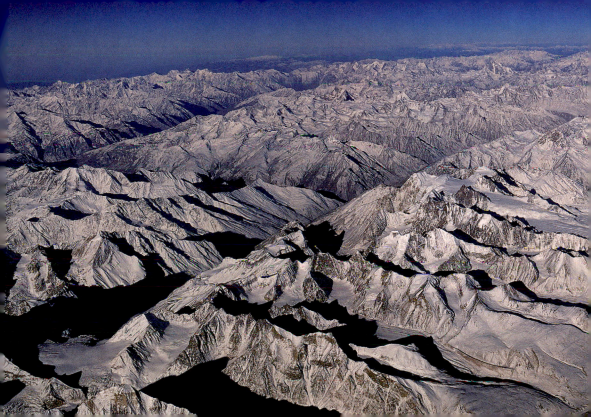

A profound understanding of religions allows
the destruction of the barriers that separate them.

Mahatma Gandhi (1869–1948)

Stones painted to resemble the *lingam* of the god Shiva, in a Hindu temple in Mandu, Madhya Pradesh.

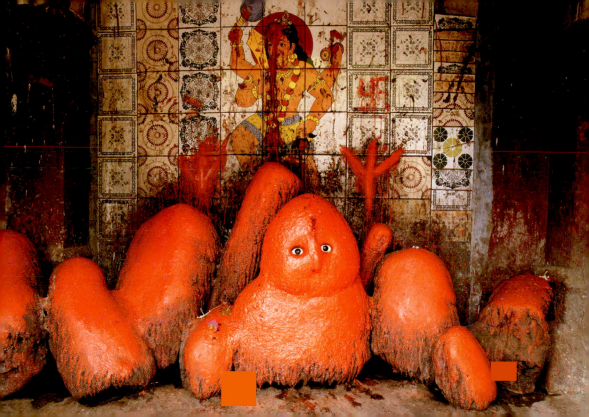

If a man reaches the heart of his own religion,
he has reached the heart of the others too.

Mahatma Gandhi (1869–1948)

This fakir travels the country from mosque to mosque, Vanarasi, Uttar Pradesh.

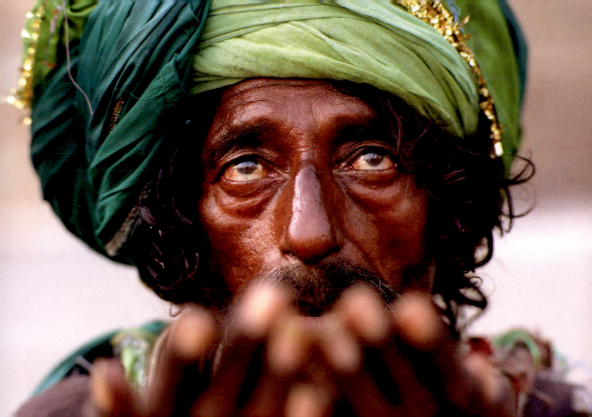

I make no distinction between one religion and another.
People may worship me in any form they wish.
The form of worship does not matter to me;
my only concern is the quality of love which is expressed in worship.
I accept every kind of worship, because I am supreme.

The Bhagavad Gita (*c.* 400–300 BCE)

The Meenakshi Amman temple in Madurai, Tamil Nadu, is richly decorated with statues of Hindu deities.

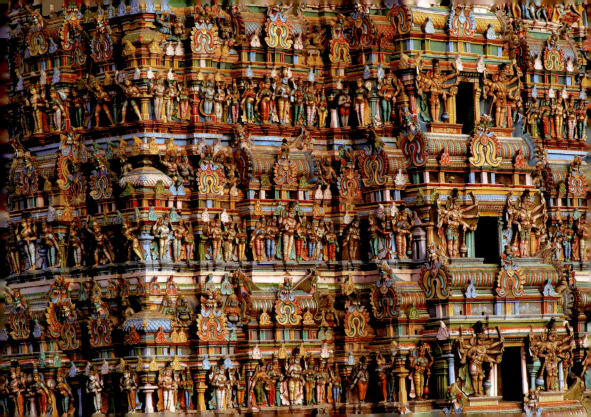

The term religion I am using in its broadest sense,
meaning thereby self-realization or knowledge of self.

Mahatma Gandhi (1869–1948)

Sumar Ram, 65 years old, in Kuldhara, Rajasthan.

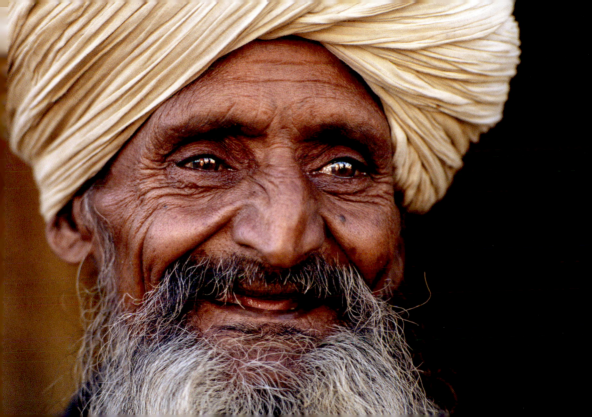

*I am proud to tell you that I belong to a religion
in whose sacred language, Sanskrit,
the word* exclusion *is untranslatable.*

Swami Vivekananda (1863–1902)

At Welham Girls' School in Uttar Pradesh, the pupils always begin the day with a prayer.

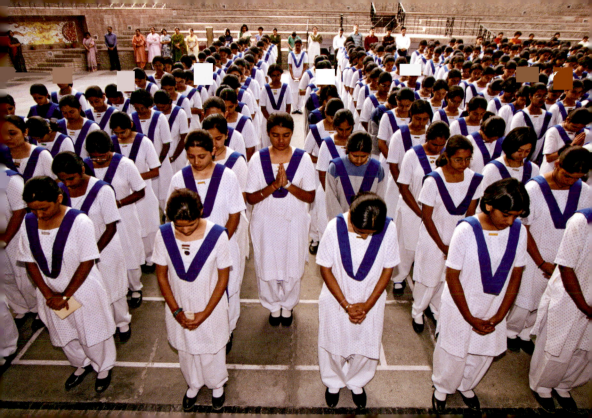

When restraint and courtesy are added to strength,
the latter becomes irresistible.

Mahatma Gandhi (1869–1948)

A team of workers in Delhi lay down a railway line.

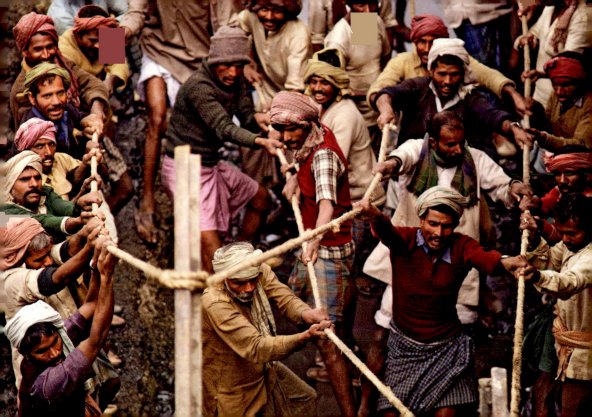

The noblest moral law is that
we should unremittingly work
for the good of mankind.

Mahatma Gandhi (1869–1948)

Giving food to the poor is a duty for all Buddhist pilgrims who come to Bodhgaya, Bihar.

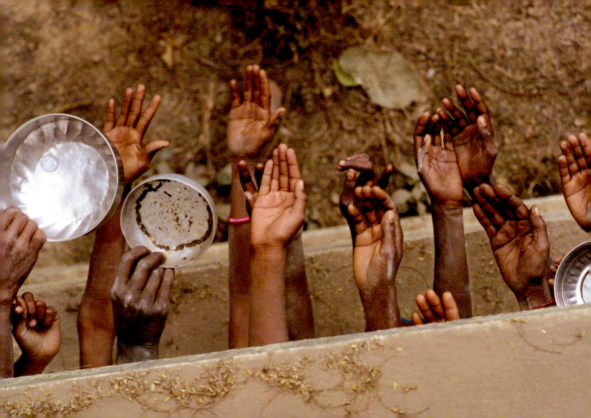

The world in its essence is the reconciliation of opposite forces.
These forces, like the right hand and left hand of the creator,
act in perfect harmony and yet in opposite directions.

Rabindranath Tagore (1861–1941)

The greeting *namasté* is made with hands pressed together. It is a recognition of the divine nature of the other.

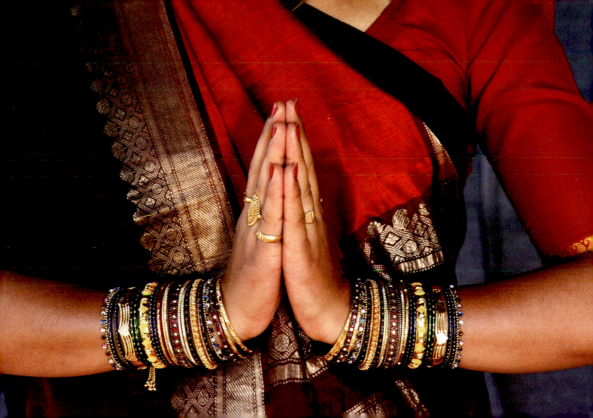

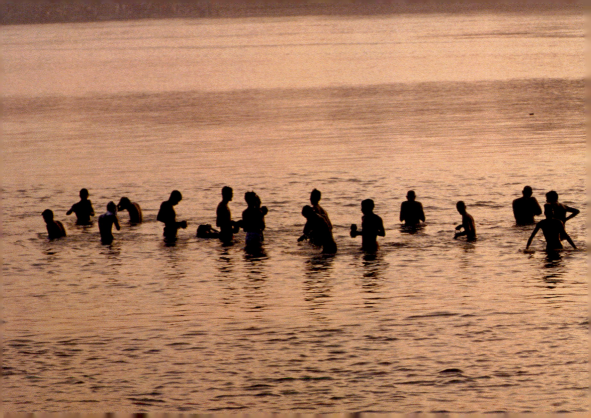

MOKSHA, LIBERATION

The soul is the home of all living beings;
and from the soul all living beings derive their strength.
There is nothing in the universe that does not come from the soul.
The soul dwells within all that exists;
it is the truth of all that exists.
You, my son, are the soul.

The Chandogya Upanishad (*c.* 500 BCE)

The west face of Kang Tokal, at a height of 6,294 m (20,650 ft), with the Dolpo mountains of Nepal in the background.

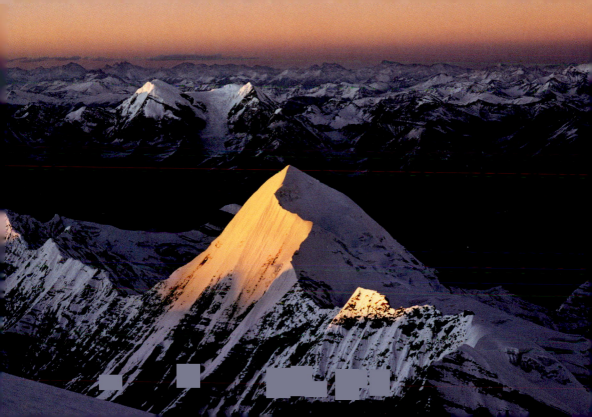

What is then worth having?
Mukti, *freedom.*

Swami Vivekananda (1863–1902)

Earth, water, fire, air and ether are the five basic elements. Rajasthan.

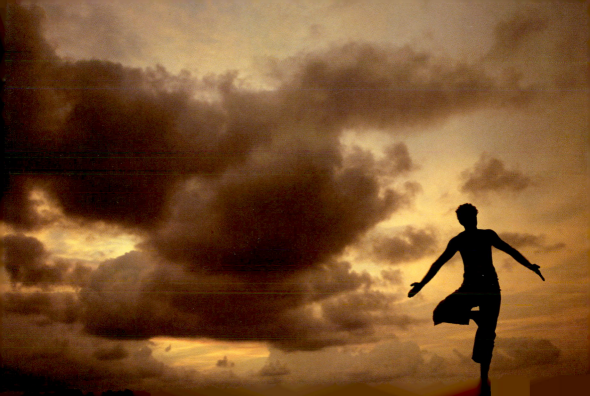

Freedom is a state of mind – not freedom from something.

Krishnamurti (1895–1986)

A young *sadhu* on a pilgrimage to the Kumbh Mela, Nashik, Maharashtra.

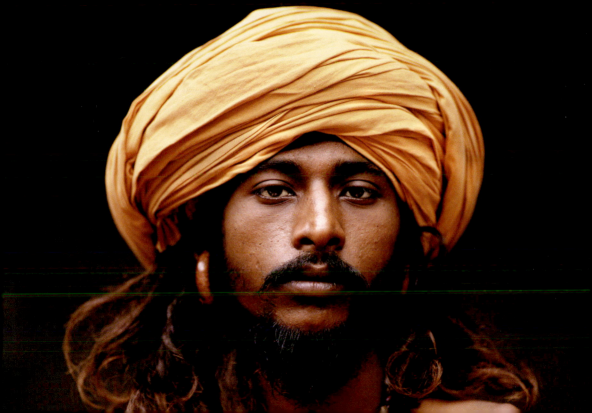

To find God, you must welcome everything.

Rabindranath Tagore (1861–1941)

Shanti, a Bharata Natyam dancer in Gujarat. The name *Shanti* means peace.

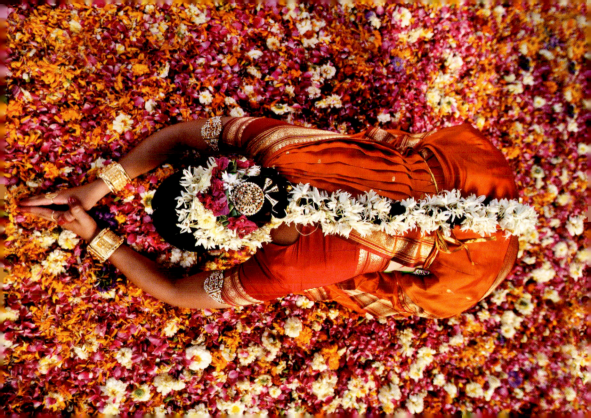

Bibliography

Sri Aurobindo, *Bhagavad-Gita*, Albin Michel, Paris, 1970
– *Trois Upanishads: Isha, Kena, Mundaka*, Albin Michel, Paris, 1972

Wendy Doniger, *The Laws of Manu*, Penguin Books, London, 1991

Mahatma Gandhi, *All Men Are Brothers: Autobiographical Reflections*,
The Continuum Publishing Company, New York, 2002
– *Quotes of Gandhi*, compiled by Shalu Bhalla, Navajivan Trust/All
India Press, Ahmedabad, 2001

Kabir, *Au cabaret de l'amour*, Gallimard/UNESCO, Paris, 1986
– *Le Fils de Ram et d'Allah*, Les Deux Océans, Paris, 1988
– *Cent huit perles*, Les Deux Océans, Paris, 1995

Krishnamurti, *Freedom from the Known*, ed. Mary Lutyens,
Krishnamurti Foundation Trust Ltd, UK, 1969
– *Krishnamurti to Himself: His Last Journal*, Krishnamurti
Foundation Trust Ltd, UK, 1987

Index of authors

Translated from the French *Sagesses, 130 pensées de maîtres de l'Inde*

The text and images in this book were first published in 2004 in
Wisdom: 365 Thoughts from Indian Masters.

Original edition © 2012 Éditions de La Martinière, an imprint
of La Martinière Groupe, Paris/Éditions Föllmi, Annecy
Photographs © Olivier Föllmi
This edition © 2015 Abrams, New York, and Thames & Hudson Ltd, London

Library of Congress Control Number: 2015936382

ISBN: 978-1-4197-1972-1

Printed and bound in Singapore
10 9 8 7 6 5 4 3 2 1

Abrams books are available at special discounts when purchased in quantity
for premiums and promotions as well as fundraising or educational use.
Special editions can also be created to specification. For details, contact
specialsales@abramsbooks.com or the address below.

THE ART OF BOOKS SINCE 1949

115 West 18th Street
New York, NY 10011
www.abramsbooks.com